Beginner's Guide to

ABSTRACT ART

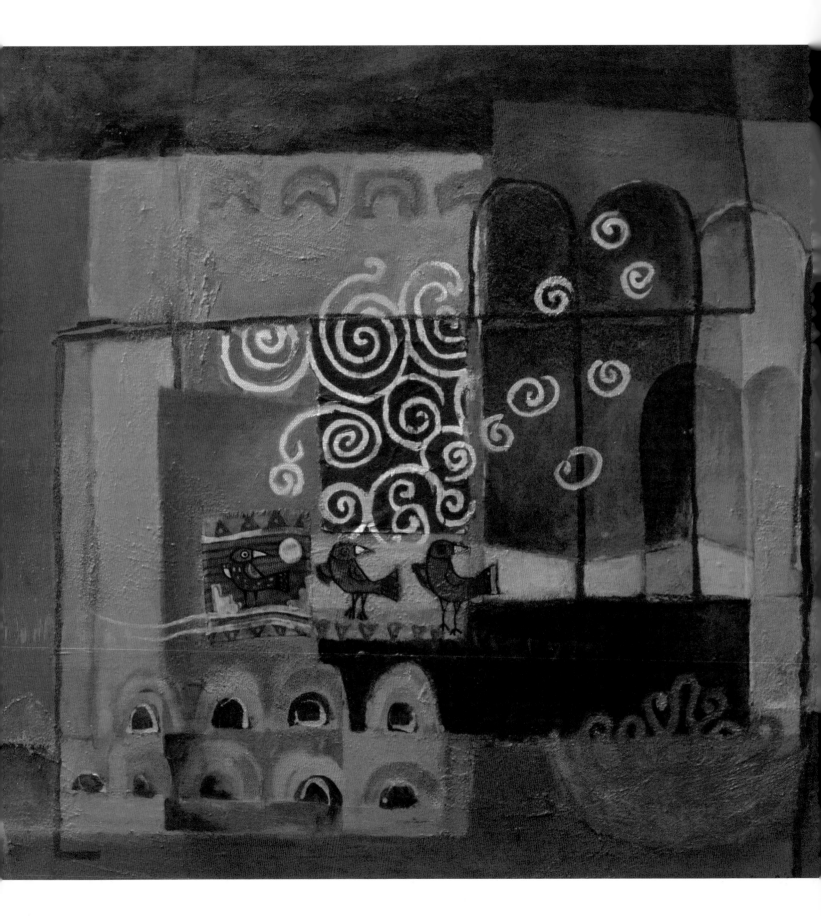

Beginner's Guide to
ABSTRACT ART

Laura Reiter

BATSFORD

First published in the United Kingdom in 2010 under the title 'Painting Accessible Abstracts'

This paperback edition published in 2014 by
Batsford
1 Gower Street
London WC1E 6HD
An imprint of Pavilion Books Group Ltd

ISBN-13: 9781849941525

A CIP catalogue record for this book is available from the British Library.

10 9 8 7 6 5 4 3 2

Reproduction by Spectrum Colour Ltd, Ipswich
Printed by 1010 Printing International Ltd, China

This book can be ordered direct from the publisher at the website
www.pavilionbooks.com, or try your local bookshop.

Distributed in the United States and Canada by Sterling Publishing Co.,
387 Park Avenue South, New York, NY 10016, USA

TITLE PAGE: COURTYARD AT THE MUSEUM
Mixed media on paper, 31 x 31cm (12 x 12in)

The courtyard referred to in this painting is one we found in a little museum
in Marrakech, which was full of colourful and multi-patterned artefacts. The
courtyard was equally decorative with tiled floors and little archways.

PREVIOUS PAGE: MADE BY HAND
Mixed media on canvas, 61 x 61cm (24 x 24in)

On a trip to South America I came across many handmade items made by local
people. This painting remembers the people and their wares, but also refers to
the ancient artifacts we found in museums. The gold object is one of these.

CONTENTS

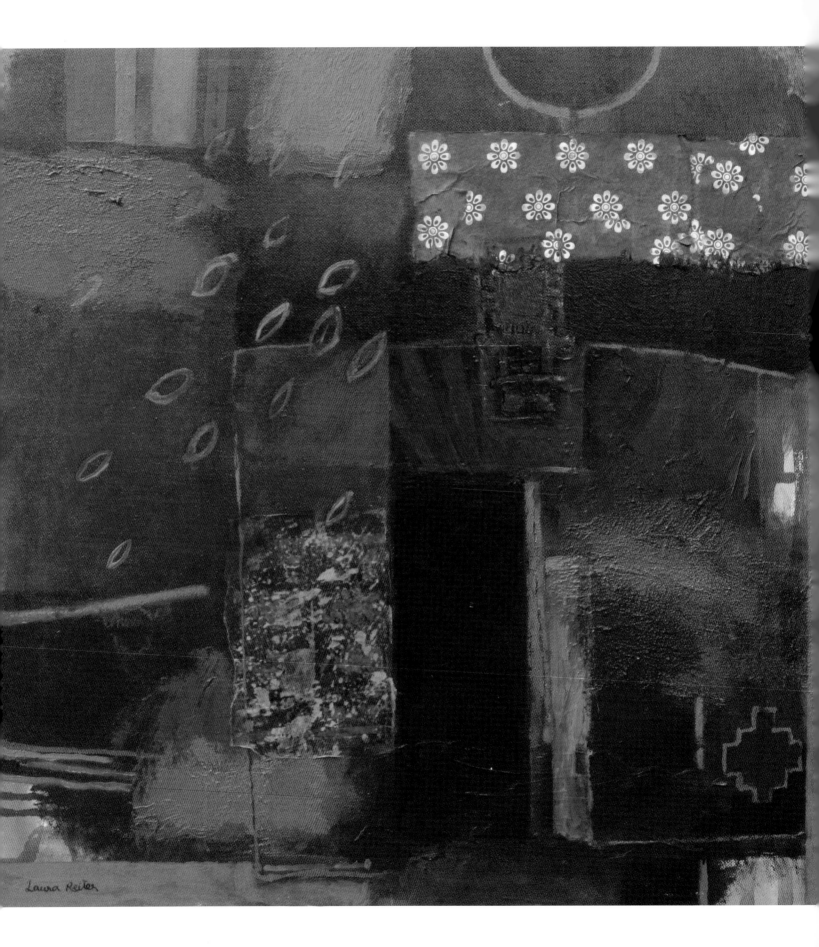

Laura Reiter

INTRODUCTION

Wassily Kandinsky, the so-called 'father of abstraction', famously declared: 'There is no must in art because art is free'. This is, indeed, an inspiring and noble thought, but finding this freedom can seem like a daunting task. I hope that this book will help you to find your way – how to produce what lies beneath a subject, not just what it appears to be on the surface. It will show you different materials and how you can use them, suggest ideas and starting points, and describe potential projects, which will help you to get results that are surprising, personal and exciting.

So what exactly does 'painting accessible abstracts' actually mean? Thanks to the innovative artists of the past, artists of today can paint a multitude of subjects – landscapes, people, still lives – and can make paintings about thoughts and ideas. In fact, anything and everything is acceptable in art today.

THE EMERGENCE OF ABSTRACT PAINTING

The late 19th and the 20th centuries saw art change at an enormous rate, beginning with the Impressionists and Post Impressionists (such as Manet, Renoir, Monet and Cezanne) who, after the invention of photography, found themselves no longer responsible for reproducing a record of the 'real' world. Instead, they were set free to improvise in their work, focusing on colour, light and emotion. Subsequently, other groups began to emerge – the Fauvists (such as Matisse and Derain) and then the Cubists (such as Picasso, Braque and Leger). More artists followed, and in the 1940s the Abstract Impressionists emerged in New York. This group, which included Mark Rothko, Hans Hofmann, Robert Motherwell and Jackson Pollock, changed painting forever, making way for artists to become experimental. Whereas in the past, art had originated from the outside, using the real world as starting points, now it became acceptable for artists to paint from within, concentrating on expressing themselves in the actual process of painting.

Thanks to all these painters, printmakers and sculptors, we artists today can be as abstract, inventive, innovative and expressive as we wish – there's a place for everyone.

WHO IS THIS BOOK FOR?

Everyone knows the word 'abstract' and that it is associated with a type of art. This book is for students and artists who feel that they would like to move on with their work, to try to paint abstract paintings, and who want to explore ways to be more personally adventurous and expressive but are not quite sure how to do this.

Many of my students say to me: 'I've got no imagination' or 'I'm really not creative in my work'. I will show you how, by being adventurous and taking some risks, by experimenting with different materials and techniques, and by following some simple projects, there are many ways in which you can learn to paint abstract paintings. If you can try sometimes to think 'outside the box' it is possible to find this creativity and imagination – it just needs to be released.

Each chapter will take you on a personal journey to new and exciting possibilities, encouraging you to keep moving and make new discoveries. This book will help you to experiment with old and new materials, to be prepared to try out new ideas, to work from outside and from internal sources, so that in time you will be able to use these ideas in ways that are entirely personal to you.

Good luck. Enjoy the journey and keep in mind the following Chinese proverb: 'To get through the hardest journey, we need to take one step at a time – but we must keep stepping'.

SUNGATE
Mixed media on canvas, 31 x 31cm (12 x 12in)

I visited some ancient ruins in a place called Tiwanaku in Bolivia. You could look through this archway with its carved figures and feel the spirit of the people who had once lived there.

1 HOW ABSTRACT DO YOU WANT TO GO?

FISHING BOATS AT ESSAOUIRA
Mixed media on paper,
31 x 31cm (12 x 12in)

Essaouira is a fishing village in Morocco. Its harbour was jam packed with blue painted boats all lined up next to each other, reflecting the blue sky, and contrasting with the coloured nets and light sand-coloured buildings.

All good paintings, be they figurative or abstract, have an abstract element, although it is more obvious in some cases than others. Paintings are not just painted – they must be designed within the rectangle of the picture plane. Their design can be described as the understructure and concerns the colour, shapes and lines that are used to create the whole. If you turn a realistic painting upside down, it is possible to 'read' it in terms of these elements. By doing this, you are not only less likely to be influenced by the reality of the objects, but you will also be able to see if they relate to each other and to the edges of the rectangle (the 'world' in which they are living). Try doing this with a painting by Edgar Dégas, for example, who was a realistic painter but also a master of design.

HOW DO YOU BEGIN?

If a painting is to be successful, the viewer must understand exactly what the artist has tried to say. For some artists, it is important to describe, in detail, all the contents of a painting, so if it is a still life, all the objects will appear as realistic as possible. However, do remember that since this is a painting of the objects and not the objects themselves, we are already one step away from reality.

Even in this scenario, the artist will have decided such things as which object is the most significant, or if the relationship between two of the objects is paramount. This will become the focal point of the painting, and the artist will set about making it more important by, say, making it central in the picture, or having other objects 'pointing' towards it. To create a picture that is more to do with the essence of the subject, the artist they may begin to eliminate details and emphasize aspects such as colour or pattern. Now the artist is beginning to abstract.

WHAT ELEMENTS DEFINE AN ABSTRACT PAINTING?

Contrary to public opinion, it is possible to go a little bit abstract, or a bit more abstract or, indeed, go the whole way and be completely abstract.

What this chapter will explore is how, when and why you might decide to create an abstract picture, be it very much or only a little bit. A painting that has been abstracted in some way, or which is a completely abstract creation, is, like all other paintings, an object or entity in itself – only more so.

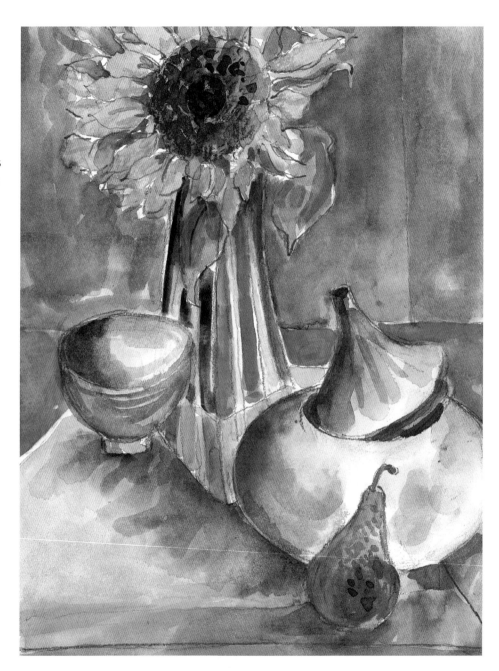

A realistic interpretation of a still life set-up with a sunflower, pots and pear, using watercolour.

DEGREES OF ABSTRACTION

Abstract paintings can be approached from two opposite ends. The first derives from recognizable subject matter, simplifying the subject or creating motifs from it. This approach has a huge range of possibilities, ranging from simplifying shapes by removing detail, to extracting so much detail that only a tiny recognizable element of the remains.

The other end of this spectrum of abstraction is when an artist starts the painting without any visible subject in front of him, but begins by exploring the qualities of line, colour, form and texture. Sometimes the end result is as abstract as it was at the beginning, leaving responses entirely up to the viewer. As the artist proceeds, a subject may emerge – for example, if the colours are, say, ranges of blues, a watery subject may push its way forward. At other times, an artist may paint instinctively, finishing the painting when it feels right. This kind of abstract artist may be happy to let the viewers decide for themselves what they see in the picture and how they interpret it using their own experiences. The 'Sunflower' (see opposite) and 'In a Moroccan Garden' (see page 14) sequences featured in this chapter are examples of the first option. Examples of the second appear later in this book (for example, see page 94).

MATERIALS AND THEIR CONTRIBUTION

If paint alone is used as a material, brush marks will make an important contribution to the overall look of the painting. In other words, lively, thick energetic marks will give the impression of movement and energy. If the surface is smooth, a quieter ambience is created. The same is true if soft or oil pastels are used exclusively.

However, using mixed media and changing the surface of the painting in some way will enhance the picture, encouraging it to take on a more independent self and become an object in itself. But, in the same way as when we use paint alone, the way in which the collage is applied – using tissue, coloured paper, texture gels or other materials – will also have something to say about the subject. If the subject or focal point of the painting is treated differently in some way – for example, if a bottle shape is shown as particularly textured or smooth compared to the rest of the painting – the eye will be drawn to this shape, making it clearer that the picture is about this bottle and it is therefore the most important element in the painting.

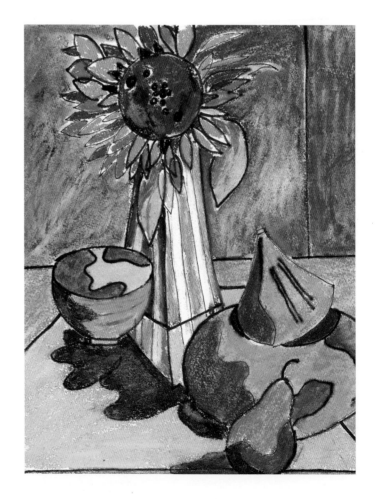

The objects are still recognizable, but all the shapes, including the shadows and pattern, are simplified. Colours remain essentially true to the objects. There is still a sense of space and three dimensions on the picture plane. Watercolour has been painted as a base, and then pen, oil and soft pastels have been applied on top.

WHEN IS YOUR PAINTING FINISHED?

The easiest (and the most difficult) way to know this is by using your instinct. This is the case with any kind of painting, although when you have real things to cling to it is easier to assess when they might look real enough. Even so, with a realistic painting, the considerations for completion are essentially the same:

- Does the design work? Is the eye being led around the painting and back again?
- Is the focal point clear?
- Does anything need to be added or (especially) subtracted to strengthen it? 'Less' is so often 'more'.
- Have you captured what you want to say?

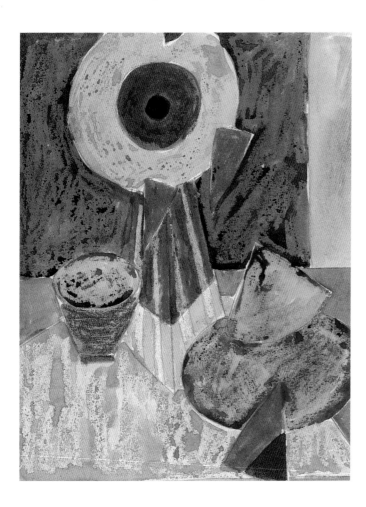

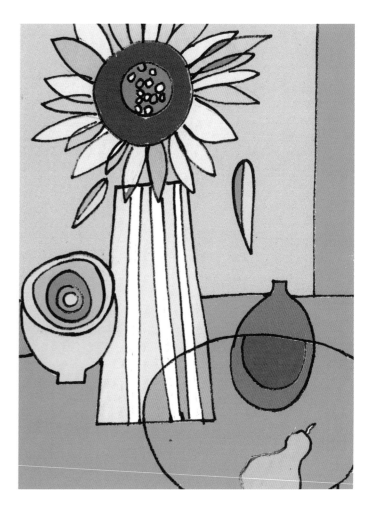

The shapes and forms have been simplified to more basic elements. The sunflower is reduced to three circles – petals and two areas of central seeds. The leaves are reduced to triangles as is the lid of the pot. A sense of space is maintained by keeping the drawing of the vase in perspective and placing dark purple behind the complementary yellow of the sunflower. Candle-wax resisting watercolour and soft pastels have been used.

Using the Photoshop program on the computer, outlines of the objects are drawn, again in a symbolic way, and then scanned. The shapes are coloured using the 'filler' tool. Colours still refer to reality but outlining is dominant.

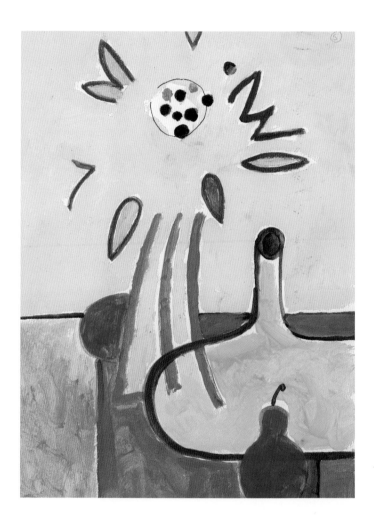

The objects have been reduced and simplified to dominant shapes and colours. The striped vase is just that – stripes – and the petals and seeds of the sunflower are presented as symbols, using teardrop shapes, zig zags and circles. The pots and pear are flattened, although it is still possible to have an idea of what the original objects were. This painting has been made in acrylic paint.

Finally, using acrylic paint and direct and lively brush marks, the favourite elements of each object and the overall appearance and appeal of the still life have been portrayed. Yellow still suggests the sunflower, together with some green. The vase is grey with a suggestive curve superimposed on top, and the forms of the pots (and vase) have disappeared altogether. The sunflower seeds are strong, dark dots – the only real reference to reality. Being darker, stronger and smaller than any other part of the painting, these dots are the selected, most important element of the set-up. The objects and their surroundings have been reduced to show the artist's favourite area of response.

IN A MOROCCAN GARDEN

This second series of paintings was created initially from a photograph of the Majorelle Gardens in Marrakech. They follow a similar path to the previous Sunflower series, but as the information in a photo is, perhaps, more finite than having real objects in front of you, I have taken a more fanciful approach regarding colours, scale and sense of space. The final version is the Photoshop version, which has been greatly stylized but is still recognizable. The later paintings have become gradually stylized, but the pond, foliage, trees, blue structures and pot are still evident, as is the basic scene.

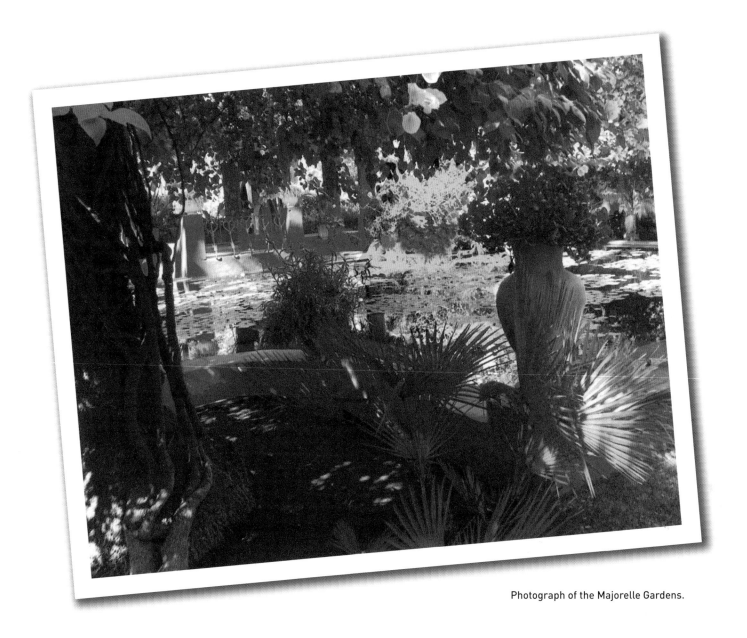

Photograph of the Majorelle Gardens.

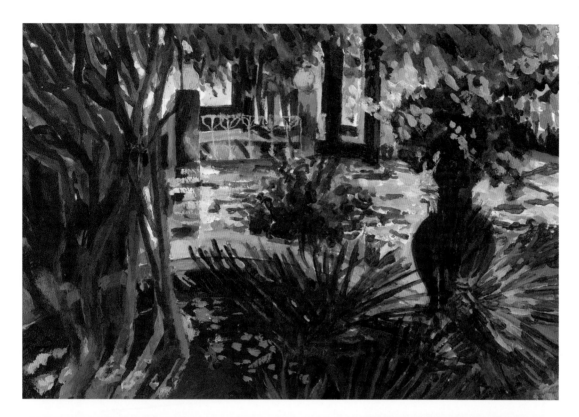

Realistic interpretation with natural colours and a sense of space. The materials used here are mainly watercolours with some gouache.

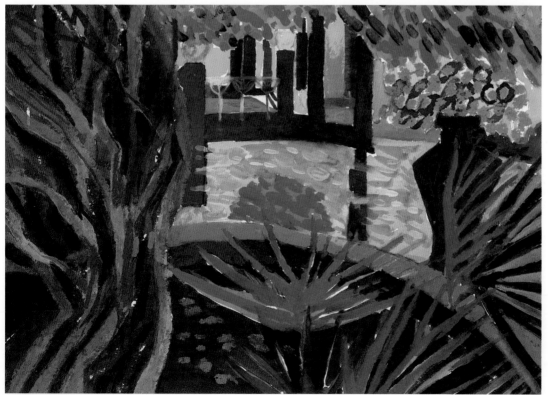

The colours are heightened and brightened, and the shapes simplified but the essential elements are still recognizable. This painting has been made mainly using acrylic paint.

The shapes have been simplified further and stylized. Some detailed shapes have been removed. A sense of distance is still maintained by the use of light and dark tones. Here I have used texture gels, acrylics and black and green ink.

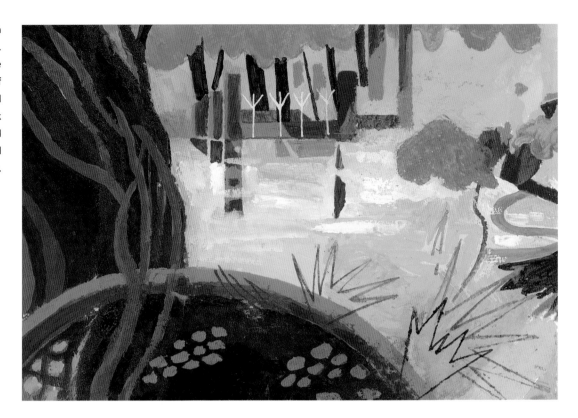

The shapes have been simplified and stylized by straightening all the lines, producing geometric shapes. They have been further abstracted by the use of patterned collage. The picture plane has been flattened by using similar tones. I have applied collage (both patterned and textured), acrylic paint and black fibre pen.

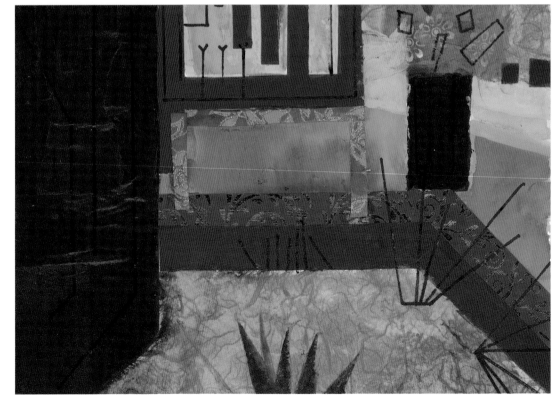

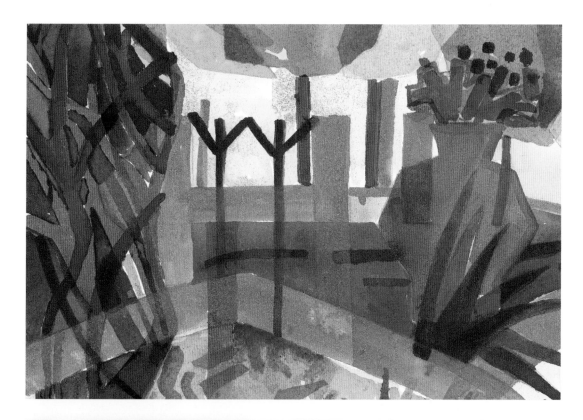

Luminous, transparent colours have been used here. There is a sense of space and the forms of the urn and leaves have returned although the urn assumes a more important place by growing in size. The geometric approach is still very evident. In this painting I have mainly used watercolours and acrylic inks.

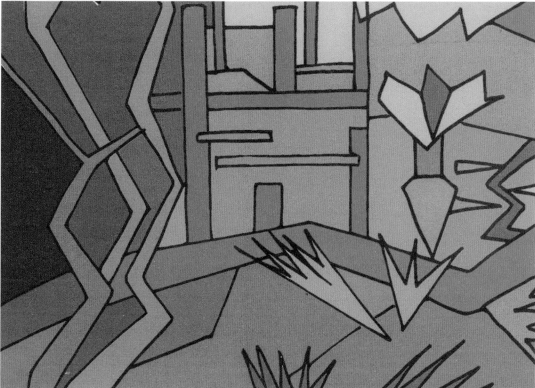

This version has been produced in Photoshop, so that all the colours are similar in quality. Outlines and stylization help to create an 'all-over' effect, which is also uniformly flat.

2 GETTING STARTED

Henri Matisse once said that 'creativity takes courage'. Indeed, getting started on something new can be daunting. Even if you have been painting in a more realistic style for some time, contemplating less representational work can be difficult. However, by deciding to take this step, you will be expanding your artistic horizons and opening up a myriad creative possibilities. By easing yourself in gently, not being too self-critical, and suspending judgment about what you think is the right way to paint, you can make great strides towards wonderful and new ways to make your pictures.

CAPE VASE AND BERRIES
Mixed media on canvas,
66 x 66cm (26 x 26in)

I often bring unusual objects back from my travels and occasionally I like to paint a kind of still life incorporating them. This vase, with its animal-style marking, has a very narrow neck, making anything that is placed in it stick out at a pleasing angle. The base is also narrow and in the painting I've placed the vase on a flimsy 'surface' to emphasize how precarious this feels.

FACE THE FEAR OF THE 'WHITE'

Are you frightened of the white? Do you fear making the mark? If so, then this chapter is for you! One of the most difficult things to do in painting is to confront the white of your paper. What shall I paint? How shall I paint it? Do I, after all, really want to paint at all? This is difficult enough when you have a subject in front of you, or at least the possibility of a subject – setting up a still life or visiting a beautiful landscape – but what can you do when you want to paint a little bit more personally, more expressively, more abstractly?

Be assured – all artists experience this, so what can you do about it? You can start by being practical and gathering up some materials. You don't need masses to begin with, although this book will give you lots of information about what materials can be used. For now, find some paper (cartridge is fine) some drawing pencils and paints (acrylics and\or watercolours) some brushes and maybe some coloured pencils (the kind you used when you were growing up) and perhaps a fibre-tip pen or two.

LOOSEN UP

The next thing is to try to 'loosen up'. Try out colours using different brushes; scribble and doodle with your pencils, pens and coloured pencils; and see what happens when you paint or scribble on top of another material. Fill up your page and when it is covered, start another. You don't need to 'make a painting' – this is about playing and trying to re-create the freedom of expression we had when we were children. Just enjoy the 'doing'.

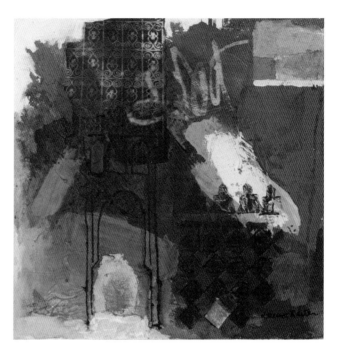

OLD PALACE
Mixed media on canvas, 20 x 20cm (8 x 8in)

The shapes in this painting come from a visit to a palace in Marrakech. There were beautiful tiled walls and floors and elaborate ironwork gates. The space in this picture is quite shallow as the colours are not only quite close in tone but also quite close to each other on the colour wheel. In fact it is quite difficult to see which shapes come forward and which go back. However, the different treatment of each of the elements – collaged, painted and drawn – helps to differentiate one element and area from another.

DISCOVERED
Mixed media on paper, 20 x 20cm (8 x 8in)

This painting is inspired by gold Peruvian artifacts. The shapes are essentially like the simple shapes in the shapes project (see page 22) – rectangles, half circles and triangles. The space is quite shallow and the shapes are either transparent (showing shapes sitting beneath) or opaque (sitting one on top of the other). The warm colours reflect the gold of the artifacts, with the odd blue complementary rectangle adding a little surprise to the hot, sunny shapes.

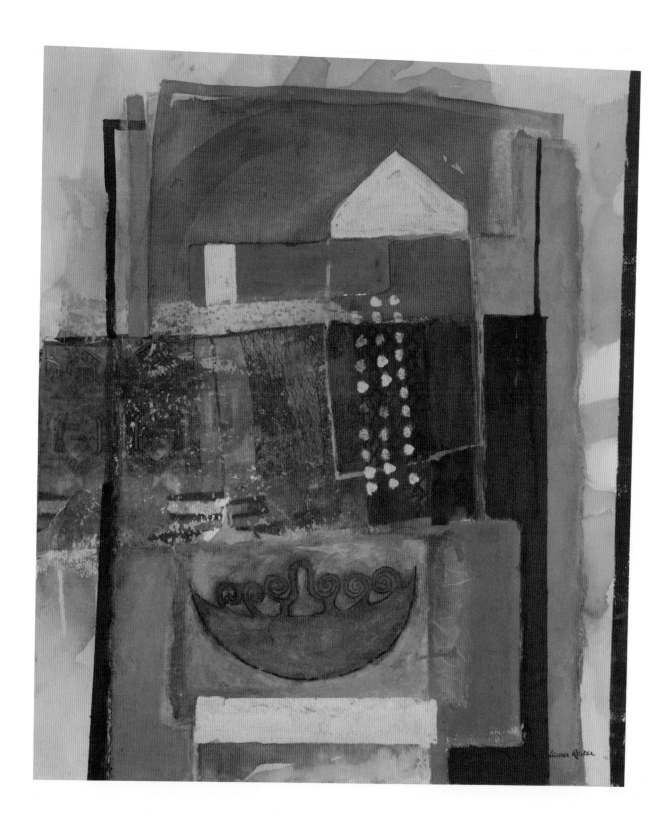

PROJECT
SHAPES

Now you have tried out materials both familiar and unfamiliar, you can apply these techniques to a painting.

DRAW SOME SHAPES
First, take a fresh piece of paper. With a pencil, draw some simple shapes, such as squares, circles and triangles as well as some 'freeform' shapes, taking up the whole sheet, and allowing some of these to overlap others to create other shapes.

DIVISIONAL LINES
Next, take a coloured pencil or pen and draw two divisional lines: one vertical and one horizontal from one side of the paper to the other. This will help to make balanced divisions of your rectangle (the sheet of paper).

COLOUR THE SHAPES
Now, using any of your materials, begin to colour in different areas. Take one colour, fill in a shape, and then use the same colour in two other places to guide the eye around the composition. Continue to do this with other colours until all your shapes are filled in. Sometimes, shapes will each have several colours in them, depending on how they are overlapping.

DON'T FORGET THE BACKGROUND AREAS
Remember that your background shapes (those created by your divisional lines) also need colouring, as shown right. The background shapes are also called 'negative' shapes and are found between the positive shapes – in this case, the rectangles, triangles, circles and freeforms. I have coloured mine using orange, purple and a blue-grey.

CREATE PATTERNED AREAS
Now draw or paint some patterned areas on some of the shapes. Again, try to confine them to a part of the design. This will focus attention and again guide the eye around the picture.

LOOK AT YOUR WORK
Finally, take a look at your work. Try to see which shapes and colours seem to be in front and which are behind. Which ones are busy and which are quiet. Do the colours 'help' each other or is there one that seems out of keeping with the design? And does the picture look attractive and feel comfortably completed?

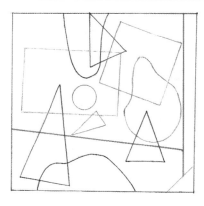

Make a line drawing of simple shapes overlapping each other. Add one vertical and one horizontal divisional line.

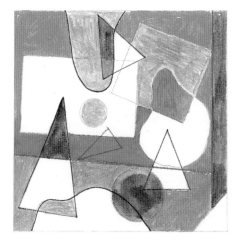

Now add colour. Here, some shapes are filled in with orange, purple and blue-grey paint and green coloured pencil.

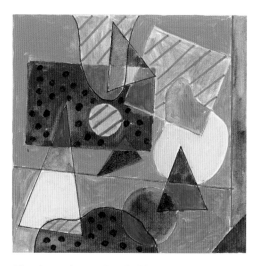

The picture is completed with yellow and green painted onto the remaining shapes and patterns (spots and stripes) added to selected shapes.

PROJECT
SIMPLE LANDSCAPES

You may also like to try this exercise, which is similar to the last one, but this time make the shapes on your rectangle look like a simple landscape. Try both these projects a few times with different shapes, colours, patterns and materials. Once you have these 'under your belt' you will be ready to move on, no longer afraid of the 'white'.

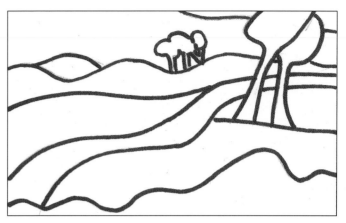

Start off by making a line drawing of a simple landscape.

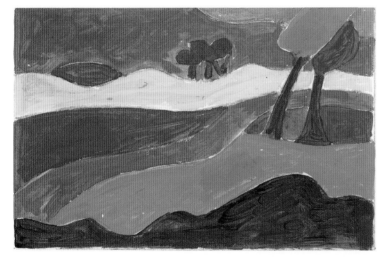

Experiment with colour combinations and try unrealistic colours. Here, bright colours in similar tones are applied with paint, creating a shallow space on the picture plane.

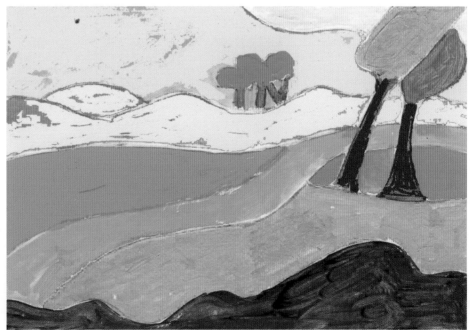

In this second version I have used the same basic landscape painting and scanned it on the computer. I have applied Photoshop colours in more realistic colours and tones. You can see that the darker tones are near the front of the picture and the lighter ones further back, creating a greater sense of space and distance.

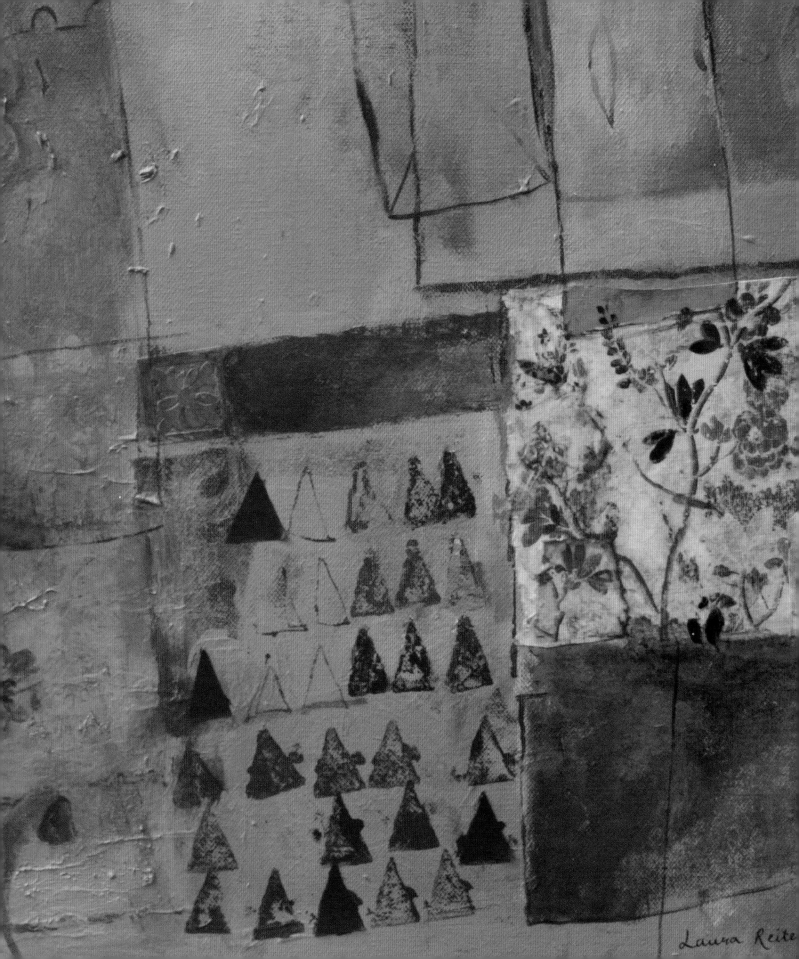

3 ADVENTURES WITH MATERIALS AND MARK MAKING

The great thing about mixed media is that you can use practically anything in the way of materials and apply them to your surface (be it board, paper or canvas) in just as many diverse ways. In this chapter, we will look at some examples of different materials, starting with dry and wet materials. We will see how different materials react when painted together and how you can alter them in various ways – by adding things to the paint, and by literally moving the paint around on the paper using materials such as cling film and bubble wrap. Finally, we will explore the possibilities of different ways of applying those materials, including using a nailbrush, splattering with a toothbrush, employing a roller or the ultimate economic tool – your fingers.

SKY SO BLUE
Mixed media on canvas, 60 x 60cm (24 x 24in)

There are references here to Venice's blue sky and also to buildings, tiled floors, little tree-lined squares and courtyards. The gold represents the opulence of Venice.

DRY MATERIALS

Dry materials range from pencils to soft and oil pastels. They are mainly used for linear work, but some, such as water-soluble pencils and pastels, can be diluted with water to create areas of colour and tone.

PENCILS

You will need pencils of all types from H pencils, which are hard, to B pencils, which are soft. The higher the H or B number, the harder or softer respectively the pencil is. H pencils make hard-light lines, whereas softer B pencils make darker, more smudgy lines. Pencils are also available in a water-soluble variety, and these can be smudged using a brush.

COLOURED PENCILS

These come in all shapes and sizes and, like lead pencils, some are softer than others. There are also water-soluble varieties, some of which are richer and make stronger, brighter marks than others.

FIBRE OR DRAWING PENS

The designer brands are usually more vibrant than other varieties. They make smooth marks and have wide, narrow and different-shaped nibs, which make accordingly sized and shaped marks.

OIL PASTELS

These resist watercolour and, to some extent, watery acrylics. They can also be found in a water-soluble format, but these will always dissolve with water and are therefore difficult to layer as they lift off. Exciting marks can be made with both.

CHARCOAL AND CONTÉ CRAYONS

These make smudgy marks, which need fixing with fixative to prevent them lifting off. They also come in pencil form, enabling smaller, more delicate marks, which are easier to control.

SOFT PASTELS

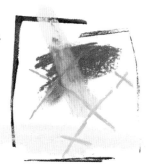

Soft pastels are delicious and can be purchased in many different varieties and makes with varying strengths of pigment. Some are softer and smudgier than others. They also need fixing with special fixative to prevent them rubbing away. If you wet soft pastel marks, they turn into painterly marks, which do not rub out.

WET MATERIALS

These include a wide range of paints and inks, from watercolours and acrylics to inks and textile paints. Their effects can be transparent, as with watercolours and thin acrylics, or opaque, and they can be layered one on top of another, either individually or with other materials.

WATERCOLOURS

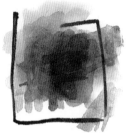

These come in two containers – tubes and pans. Again, there are many different brands and these vary considerably in quality as well as price. However, they all act in a similar way in so far as they are meant to be painted transparently, always allowing the white of the paper to be evident – they should not be completely opaque or sit on the surface like acrylics or oils. Watercolours stain the surface and so, as a rule, they are relatively permanent, although they can be reduced to a pale stain using a sponge.

GOUACHE

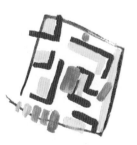

Gouache paint is like watercolour and can be painted similarly. It differs from watercolour in that it contains a white filler, such as chalk, which makes it much more opaque, with greater hiding power. It was developed with designers and illustrators in mind, who required coverage and brilliance rather than permanence, so it is not always as lightfast as the equivalent watercolour. It can be used thick for texture or diluted with water.

ACRYLICS

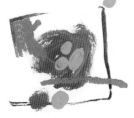

Acrylics are a fantastic medium. They can be painted like watercolours by mixing them so that they are watery, or they can be applied thickly and opaquely like oils. They are a very versatile medium and invaluable for mixed-media artists as they will paint over practically any kind of surface.

LIQUID ACRYLIC INKS

These come in little bottles with a pipette lid. They have the same permanence as tube acrylics but are an extremely vibrant version and are available in many colours, which can be layered on top of each other, mixed together, or layered on top of other materials.

LIQUID WATERCOLOURS

Although these look similar to liquid acrylics, they act like watercolours. They are, however, slightly more vibrant than ordinary watercolours as they have a high content of pigment.

DRAWING INKS

These are similar to the previous two materials and can be applied with a pen or a brush. They are beautifully transparent one over another.

HOUSEHOLD PAINT

This may seem like a surprising choice, but it is relatively cheap, can be bought in little match pots and makes a good contrast to other materials as most household paints tend to be very flat and opaque.

TEXTILE PAINTS

Available in squeezy tubes, these come in many different selections. Once squeezed onto the surface they dry to a three-dimensional line. They can be glittery, pearly or shiny.

WATERCOLOUR +

Watercolour will resist certain oil-based materials, including oil pastels and candle wax. The resistance with oil pastels is spectacular, especially with contrasting colours, while candle wax can be used to create lines, shapes and textures.

MASKING FLUID

You can also create interesting effects with masking fluid, a rubber solution that you can paint onto your paper. Wait for it to dry and then paint over the top. The fluid will protect the paper it is covering, and when the paint is dry, you can rub off the mask to leave the white paper beneath. If you paint a colour first, the masking fluid will protect this and that colour will be revealed once the fluid is removed. However, a word of warning: if using a brush to apply the masking fluid, make sure you wash it with soap or washing-up liquid straight away as it quickly dries and will ruin your brushes. Try applying it with a cotton bud or use a bottle with its own applicator.

SALT

Some substances, when added to watercolour, will affect their appearance. The most common of these is salt. Experiment with different kinds of salt – table salt, sea salt and even dishwasher salt. Just sprinkle the salt (not too much) onto wet watercolour paint – the paint must be wet or the salt will not work – and then leave it to do its job. When the paint is dry, brush the salt away.

OTHER EFFECTS

Blotting is another way to affect the paint. By using different absorbent materials, such as kitchen paper, cotton wool and tissues, you can create a whole range of lovely textures. Lastly, try pressing some cling film or Bubble Wrap onto wet paint. Leave to dry naturally. When these are removed, a beautiful and exciting texture will remain.

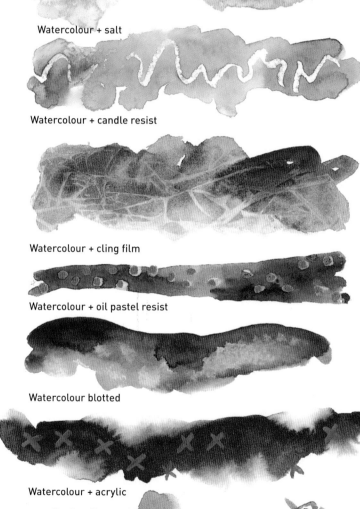

Watercolour + salt

Watercolour + candle resist

Watercolour + cling film

Watercolour + oil pastel resist

Watercolour blotted

Watercolour + acrylic

Watercolour layered, using masking fluid to create white line

ACRYLICS +

Acrylics can work in a similar way to watercolour, although they may not react so well to the resists described previously. To be really effective, only very watery acrylic paint should be applied.

VERSATILITY

The best thing about acrylic paints is their versatility. They can be used like watercolour or oil paint and are equally, if not more, covering. For instance, by painting white acrylic over black you can obliterate it. The covering quality of the paint also works well when drawn or written over with drawing inks and pencils. It is especially good when working over collage and building up the surface of a painting. Its liquid form – acrylic ink – is available in vibrant and brilliantly transparent colours, which can be painted on with a brush but are equally good applied with a nib pen. They react in a similar way to watercolour when other substances are added or when using cling film or bubble wrap.

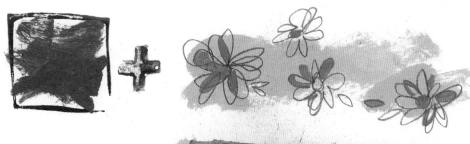

Acrylics + pencil

Acrylics + coloured pencil

Thick acrylic + oil pastel

Acrylics + fibre pen

Acrylic ink + wax crayon resist

Acrylic ink + textile paint

Acrylics + acrylic inks

Acrylic inks + black drawing ink

APPLYING YOUR MATERIALS

There are many ways of applying materials, and the only general rule is that if it works, it's OK. You don't have to use a brush and you can have fun experimenting with different applicators. For example, try scratching out with the other end of the brush or just a twig from the garden. You can also draw using a twig as a pen or, finally, when all else fails, use your fingers.

Here are some of the alternatives to a brush.

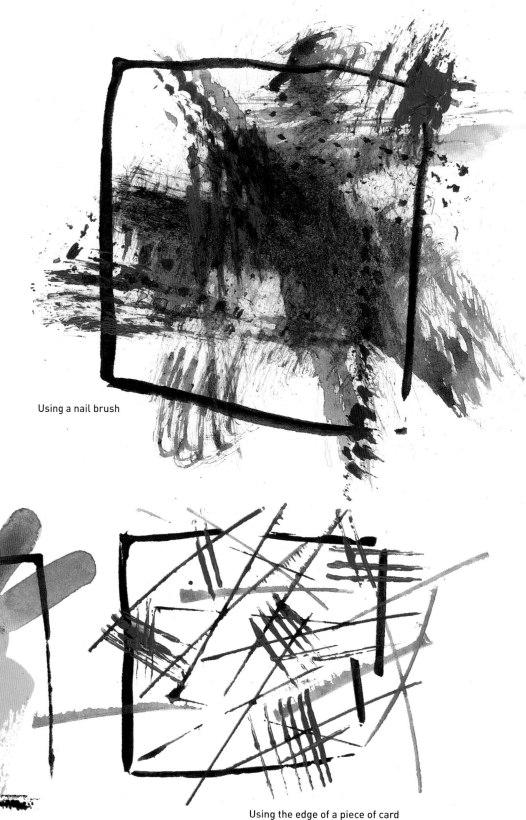

Using a nail brush

Using your fingers

Using the edge of a piece of card

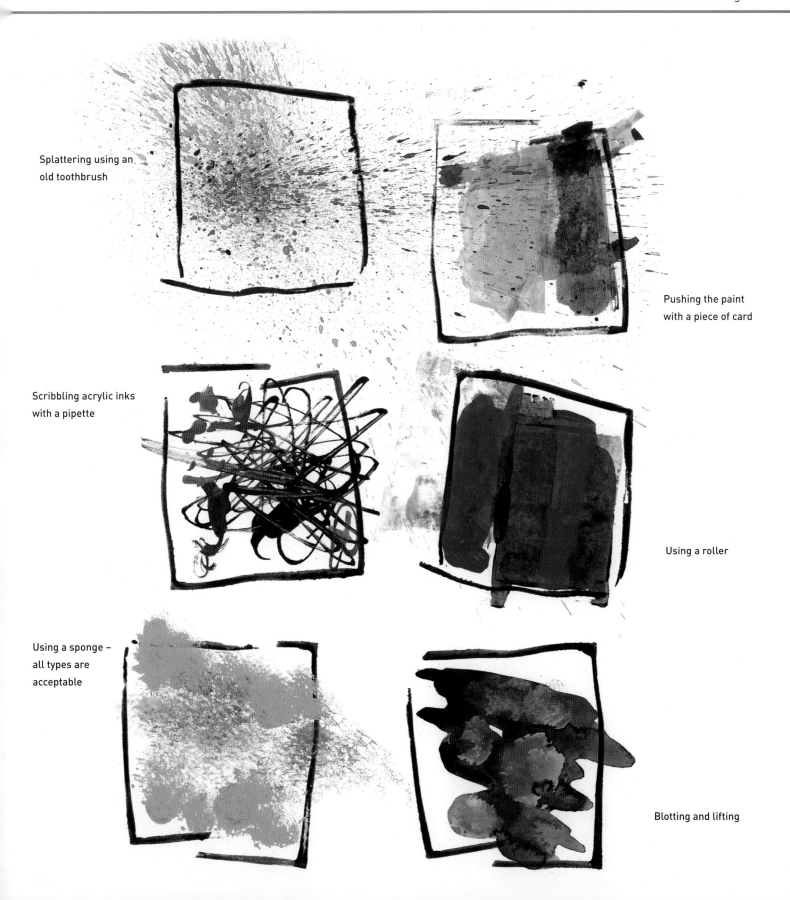

Splattering using an
old toothbrush

Pushing the paint
with a piece of card

Scribbling acrylic inks
with a pipette

Using a roller

Using a sponge –
all types are
acceptable

Blotting and lifting

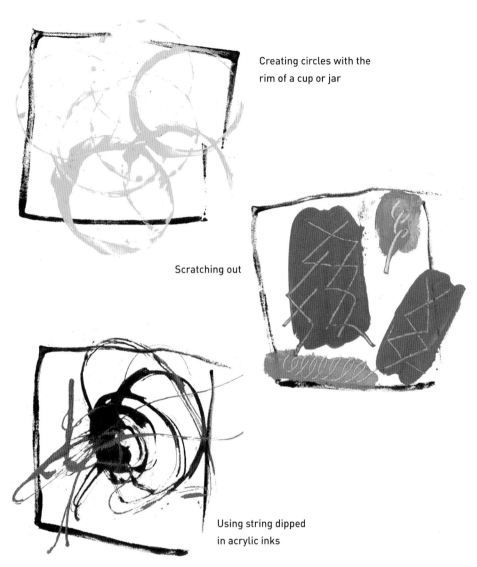

Creating circles with the rim of a cup or jar

Scratching out

Using string dipped in acrylic inks

KEEP EXPERIMENTING

The main thing to take away with you from this chapter is that it is important to keep on experimenting with materials. Don't be afraid to try things out, and learn to play. In this way, you will have a world of marks at your fingertips waiting to be used for wonderful paintings.

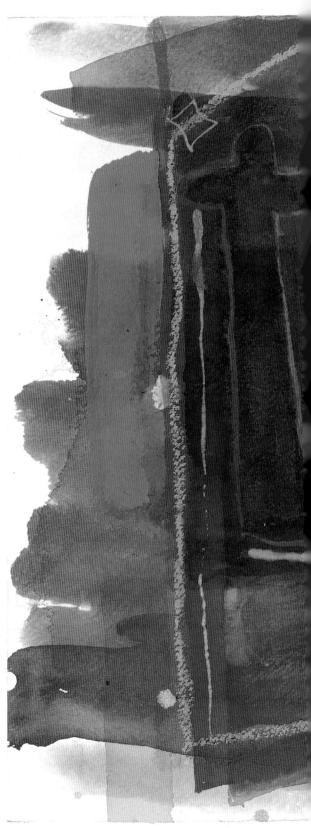

STAINED GLASS
Mixed media, 25 x 35cm (10 x 14in)

A stained glass interior is captured here by experimenting with different methods of mark making.

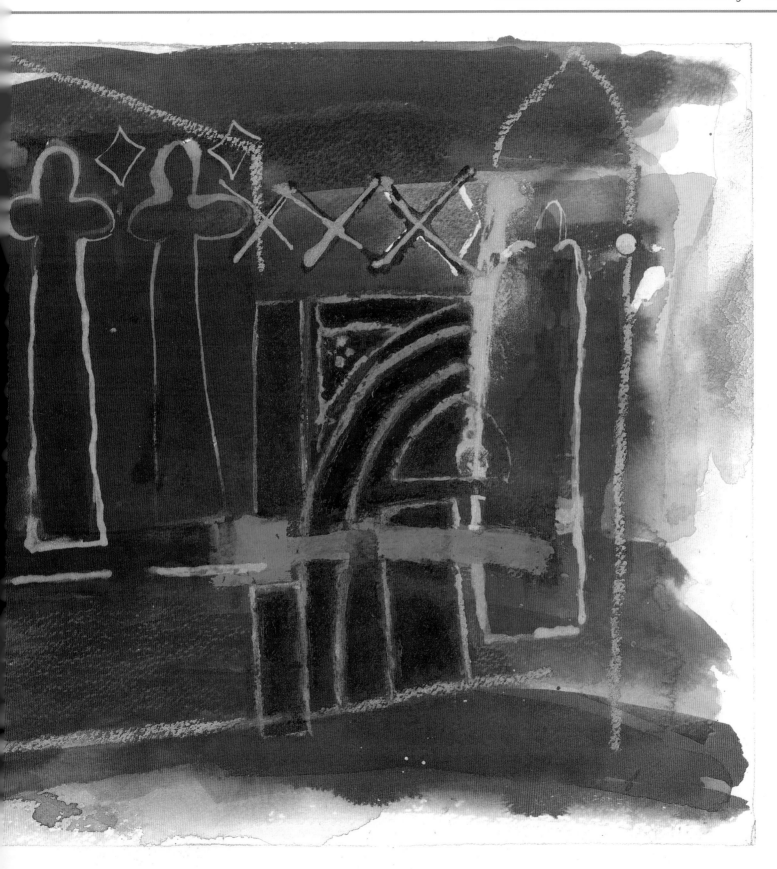

4 TEXTURE, COLLAGE AND SIMPLE PRINTING

We have seen how many wonderful materials are accessible to us and the ways in which they can be applied, mixed and combined. The journey continues in this chapter as we look at building up the surface of the paper, board or canvas with collage and other materials, as well as simple printmaking – applying paint with stamps and tools in order to print whole shapes. By creating different surfaces (to imitate real textures and surfaces or to help the picture become the subject), by printing different images (allowing for repetition) or by applying printed images (adding context or a narrative), it is possible to expand on an idea and add infinite interest to your work.

MEDINA
Mixed media on canvas, 20 x 20cm (8 x 8in)

The Marrakech medina is a crowded, bustling place packed with hundreds of stalls. I have collaged the little pearly stars to represent the treasures on sale and used red to evoke the hot, exotic atmosphere.

BUILDING UP THE SURFACE

There are many ways to build up the surface of your painting, and some of the commonest ones are featured below.

COLLAGE

There are so many possibilities that it is impossible to list them all. Start collecting as many papers and materials as you can find and keep them in an art bag – I call this my 'goody bag'. Everyday papers that you can rescue and save include tin foil, wrapping papers and even wallpaper (the textured kind is particularly useful). Use plastics, such as Bubble Wrap, plastic bags and netting from fruit bags. When stuck down, these create very particular surfaces, which look great when painted over with acrylics. Then there are art materials – tissue and crêpe paper (particularly nice when painted over with watercolour). There are also a multitude of embossed papers, papers with glittery patterns (some of my favourites) and webbing. Scrim, a type of material that resembles netting, makes a lovely surface to paint on, and can be found in art shops. All these materials are suitable for sticking to your surface, and PVA is the best glue for this.

TEXTURE GELS AND GESSO

Next, there is the texture you 'paint' on. Texture gels are adhesive mediums with added textural 'bits', such as sand or glass beads. They can be applied to the painting surface or mixed with the paint. Gesso is a kind of paste, which, when applied to a board or canvas, can create many different textures, either by using a palette knife or spatula, or by drawing into the surface while it is still wet. It should be allowed to dry before painting on top. However, the simplest way to make a textured surface with a liquid is by using 'neat' PVA glue, which will resist watercolour paint when dry.

OTHER TEXTURES

Finally, there are a few more unconventional ways to create a textured area:

- Shave soft pastels into a powder and scatter them onto an area coated with PVA glue.
- Create 'frottaged' papers – frottage is a kind of rubbing. Place a piece of paper on a textured surface, such as rough flooring, tree bark or woven fabric. With a soft pencil or crayon, scribble on the surface, making shading marks on the paper. The texture will be picked up, creating a similar surface. Do several of these. They can be torn or cut up for collaged areas.
- Use the little paper circles you get after using a hole puncher.
- Stick on beads, buttons or other small objects.

Be adventurous – PVA will stick almost any object or material to any surface. Keep a sketchbook for trying out different textures and paper, so that when you need an idea they will be accessible.

Acrylics over tin foil, drawn into while wet

Ready-made patterned papers painted into

Masking tape applied and painted over

PVA glue applied, dried and painted over with watercolour

Textured wallpaper

Various ready-made textured papers

Shaved soft pastels dropped onto PVA glue

Ready-made patterned paper

Cling film stuck down and painted with acrylics

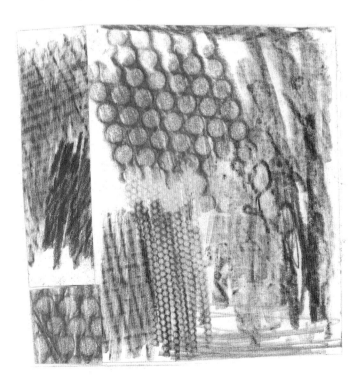

Frottage (rubbing over textured surfaces)

Centres of holes from a hole puncher

Texture gels – natural sand, glass beads and medium texture

Bubble Wrap stuck and painted with acrylics

Tissue paper

Ready-made textured papers with beads

Fruit netting and scrim

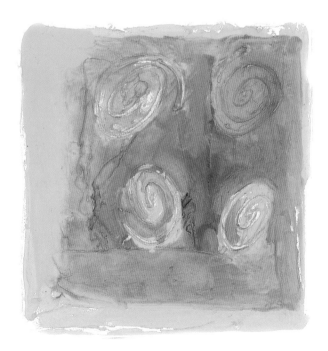

Gesso, drawn into while wet and then painted with acrylic

Webbing, painted with acrylic inks

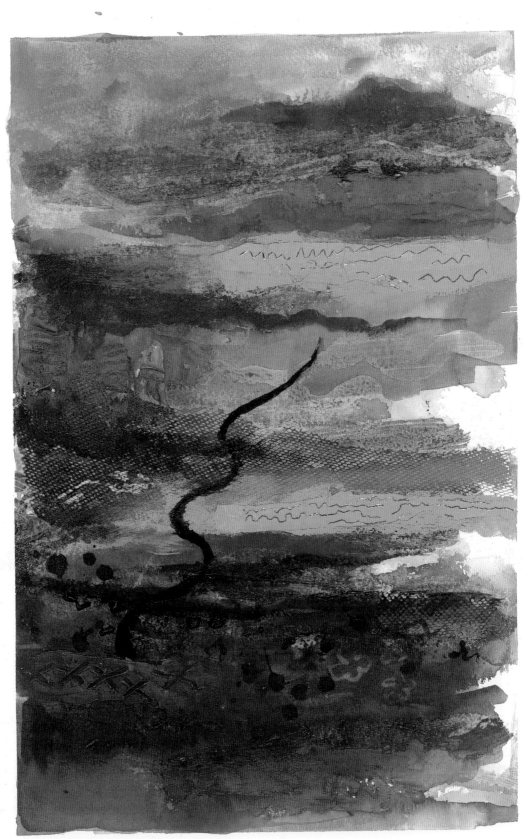

PURPLE PATH

Mixed media with collage,
23 x 35cm (9 x 14in)

Building up the surface of the
painting by layering different
materials is a great way to create
texture, depth and atmosphere.

SIMPLE PRINTING

It is possible to print without using a press. The value of printing is that it offers you the possibility of creating the same kind of mark more than once. Most of the following methods are kinds of 'stamping'. These are some of the many 'stamps' you can make and use.

POTATO PRINTING

Yes, this is just like what you used to do at school. Cut a potato in half and scoop out shapes into the surface and around the edges. Then paint with acrylics and stamp onto your composition.

CARD PRINTING

With some firm card and a variety of materials it is possible to make many different marks and images. Take your card and cut a rectangle out to make a base. Onto this card you could:

- Stick cut-out shapes of the same card, such as hearts or triangles. Paint the raised pieces – watercolour or acrylics are suitable for this and will each create a different mark. Print as for potatoes. To get a better impression, you can place the paper over the card and burnish (rub) with the back of an old spoon, or use a roller.
- Coat some pieces of card with PVA glue. Curl some string into different shapes on the surface. Allow to dry well, then

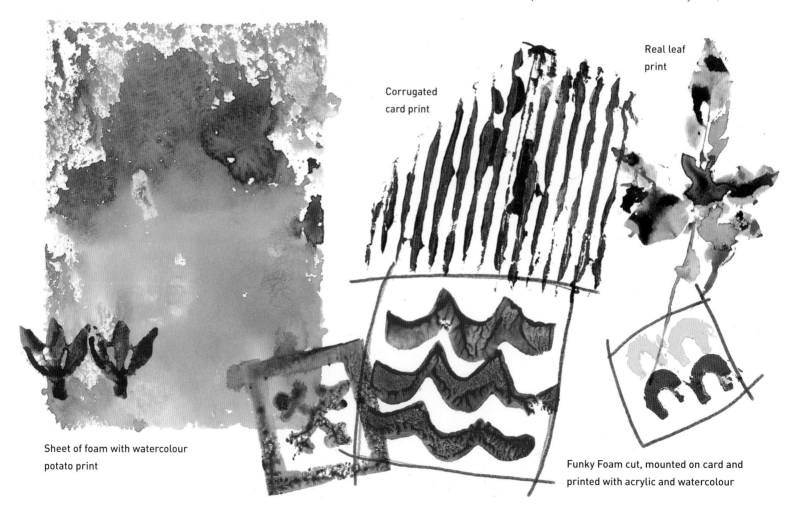

Corrugated card print

Real leaf print

Sheet of foam with watercolour potato print

Funky Foam cut, mounted on card and printed with acrylic and watercolour

paint acrylic or printing ink onto the surface with a brush or roller and print as before. This is a great way to make spirals and curvy shapes.

- Foam pieces – rectangles of thin 'rubber foam', such as Funky Foam (also sold in ready-cut shapes) – can be purchased in craft shops. This is a great material because you can cut it out easily into quite intricate shapes. Stick the shapes onto your card as before and print.

OTHER METHODS
As a rule, anything that transfers an image from one surface to another is printing. Try these:

- The base from a home-bake pizza.
- Leaves and petals.
- Corrugated card.

You can also buy ready-made stamps, made from wood, foam or rubber, with complicated and intricate designs. Cheaper versions can sometimes be found in DIY shops.

Another possibility is to make or buy stencils, which can make delicate markings. Alternatively, you may like to try a method that Paul Klee made famous, which is not strictly printing but creates an interesting surface. Firstly, coat a plastic surface with acrylic paint. While this is still wet, place your paper over the top, and then another thin sheet of paper over the top of that. Draw your image hard with a pen or sharp pencil. The image you get will be a line drawing with bits of paint printing around the line. You can also do this with old-fashioned carbon paper.

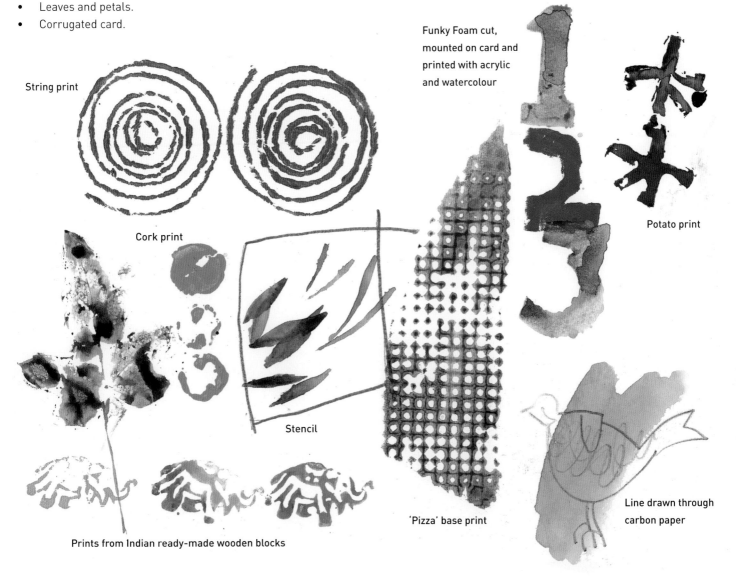

String print

Cork print

Stencil

Prints from Indian ready-made wooden blocks

Funky Foam cut, mounted on card and printed with acrylic and watercolour

Potato print

'Pizza' base print

Line drawn through carbon paper

THE PRINTED IMAGE

Many 20th-century artists used the printed image as collage. Picasso and Braque were the founding fathers of this genre. Any printed image, from newsprint, wallpaper and maps to music sheets and cut-up photos, can be used. Try also sweet papers, labels, tickets, old and foreign bank notes and wrapping paper.

If you use a printed image there needs to be a reason for doing so. You may wish to add narrative, context or just create movement – vertically placed text moves up or down whereas horizontal text creates a base. Don't be afraid to partly paint or cover with transparent watercolour, but remember that cut-out and torn shapes are read by their edges, and you must take this into account when composing your paintings. Collect them at home or on your travels and add them to your goody bag for future use.

As we have seen, painting with mixed media is an ever-expanding activity, allowing artists to create and re-create their surfaces, building up pieces of work and enabling them to become 'objects' in their own right.

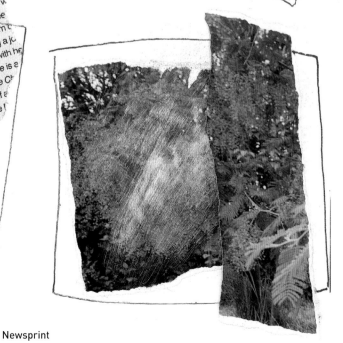

Patterned wallpaper

Tickets

Magazine picture

Scratched photo

Newsprint

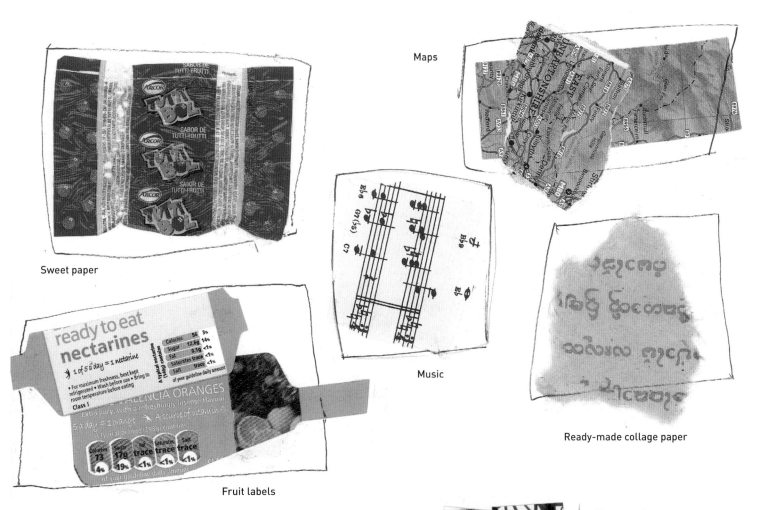

Sweet paper

Maps

Music

Ready-made collage paper

Fruit labels

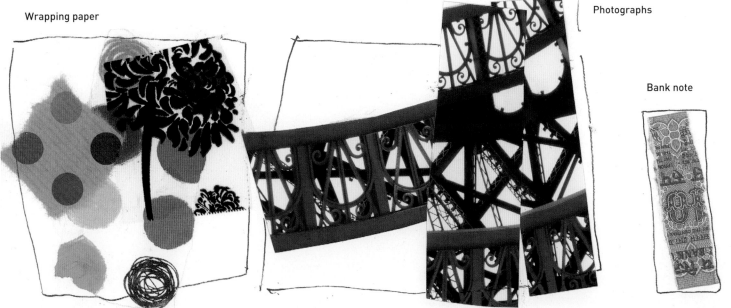

Wrapping paper

Photographs

Bank note

DIFFERENT INTERPRETATIONS
MIKE BERNARD

Mike Bernard's mixed-media paintings are vigorous and exciting. They show snapshots of people's lives, be they in little seaside towns, lively ports or larger cities. He uses collage and texture extensively to create exciting surfaces and also to help tell a story. He works in layers, firstly with washes of watery paint, then perhaps applying tissue paper before adding patterned papers and paper with text, which often gives the viewer a clue about the place or objects within the scene. Then he adds more paint, creating abstract patterns among the hints of more recognizable objects, such as boats, buildings and people. Sometimes, the collage itself will help describe a section of a wall or perhaps part of a boat. The overall effect is one that allows the viewer continually to find new areas to look at and enjoy.

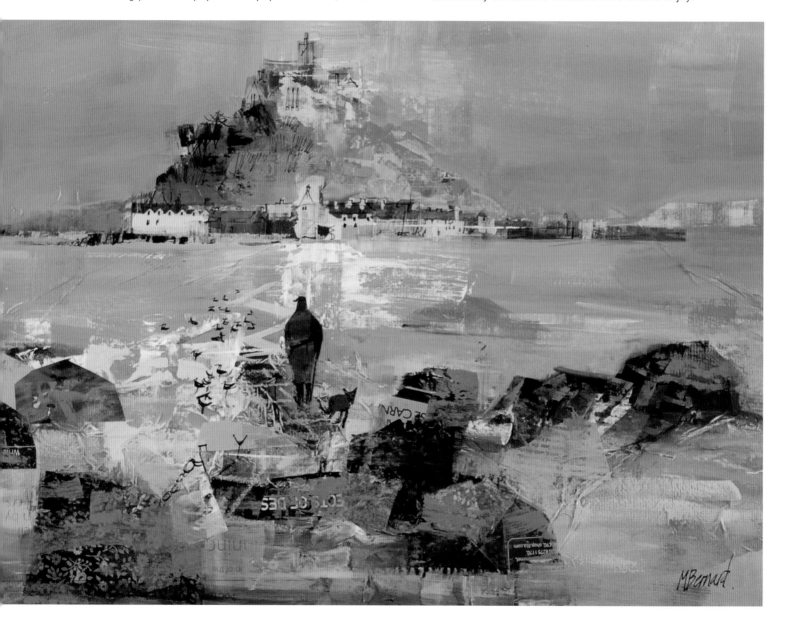

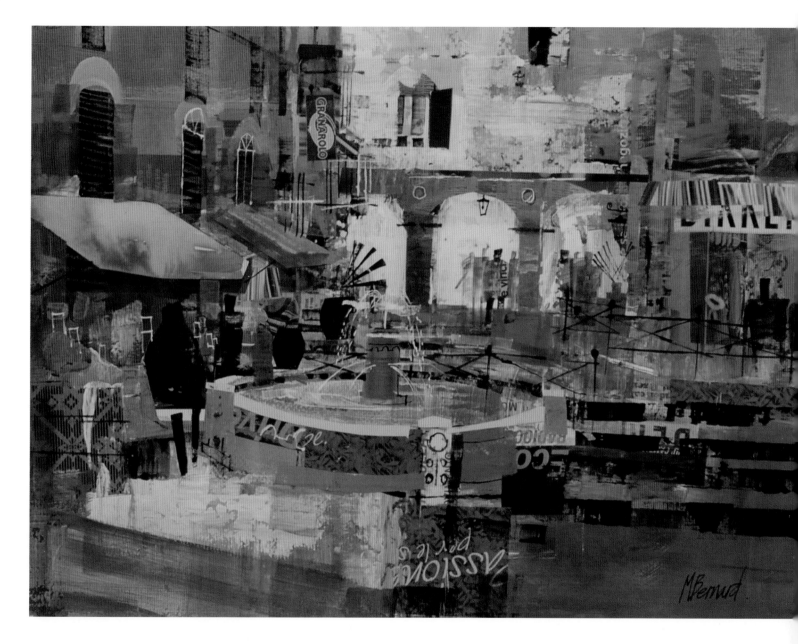

RIVA, LAKE GARDA
Mixed media on paper, 30 x 40cm (12 x 16in)

ST MICHAEL'S MOUNT
Mixed media on paper, 35 x 50cm (14 x 19.5in)

I love the looseness of this picture, which Mike Bernard beautifully
achieves with his multi-layering of collaged papers and broad,
lively brushstrokes. There is also a wonderful sense of light and
a charming quirkiness in the almost centrally placed figure and
his little dog.

This painting captures a little square full of cafés where people can
escape from the heat of the day. Again, collage plays a large part in the
piece, giving life to the architecture and fountain, which are more of a
focus than the transient silhouetted figures.

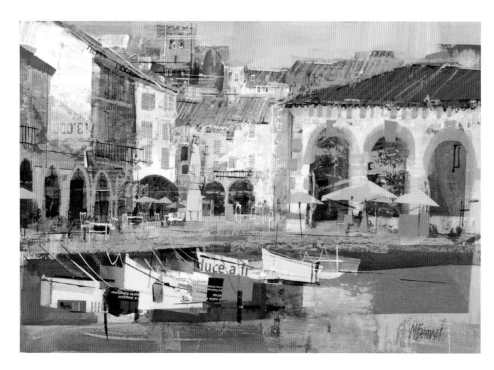

DESENZANO, LAKE GARDA

Mixed media on paper, 30 x 44cm (12 x 17½in)

This painting, with its contrasting sunny colours, describes a light, colourful and peaceful scene. The textured marks and, especially, the collaged text emphasize the long life of this place, which dates back to the first century BC and is now a bustling city.

CORNISH HARBOUR COTTAGES

Mixed media on paper, 35.5 x 58cm (14 x 23in)

Pieces of collage, areas of text and criss-crossed lines suggest the hustle and bustle of a busy harbour. Even the simple seagull shapes seem to contribute to this atmosphere. The complementary orange areas contrasting with the blue boats lead cleverly to two small figures strolling down some steps.

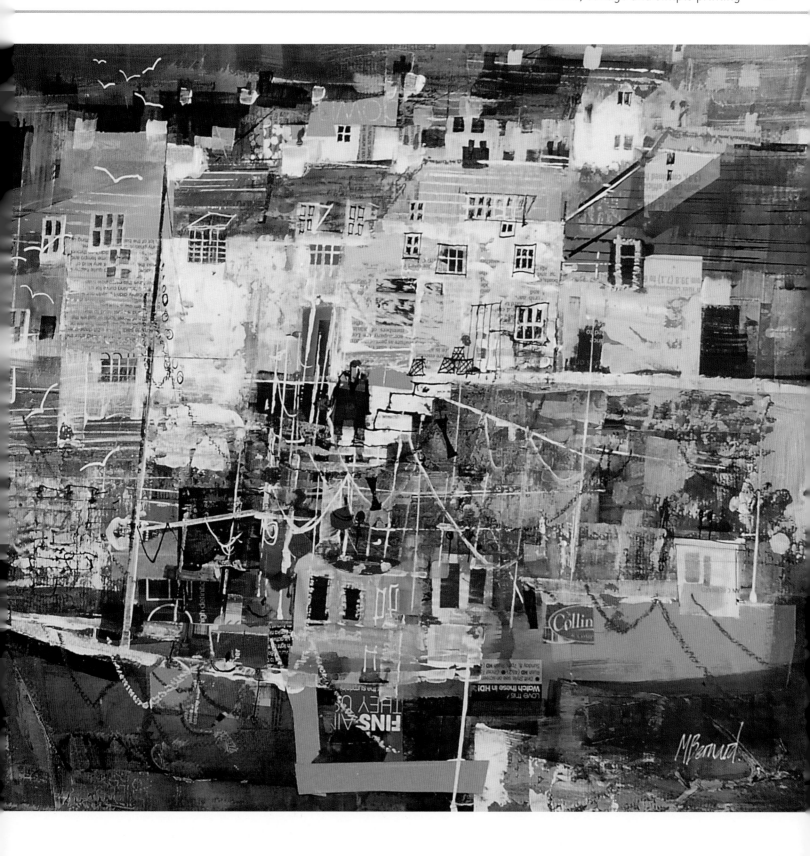

5 COLOUR AND MEANING

This chapter is about colour: its properties, qualities, uses and meaning. It is important in all kinds of art but has a special importance in abstract art since it can not only tell stories and enhance ideas but it can also alter the visible surface of a painting and, indeed, be the actual subject of the painting itself. It has even named a movement in art from the 20th century – Colour Field painting. Artists such as Morris Louis, Mark Rothko and Clifford Still were prominent in this genre. It is, for me, the single most exciting and important aspect of painting.

GREEN FIELDS OF GOLD
Mixed media on paper,
17 x 22cm (6½ x 8½ in)

Complementary colours (green and red)
are used in this painting about fields and
the outdoors. Green represents grassy
areas and the flashes of red perhaps
suggest red flowers or plants.

WHAT IS COLOUR?

Colour is all around us and the world certainly would be a more boring place without it. But what is colour? Scientists tell us that it is all about light and the more we have, the more intense colour will seem. When there is less light – when the sun goes down or electric lights are turned off – colours turn to greys or neutralized versions of those bright colours. Think of walking down a street after dark when only street lamps are providing light.

As with all aspects of picture making, you need as much knowledge as possible about colour and how it can be used. Once you have studied the following colour terminology, look at the illustrations and begin to experiment yourself, trying out combinations of colours and seeing what happens when you do this. Try to use different materials because, as you can see from the colour wheel, different materials look very different even when the name of the colour is exactly the same.

USEFUL TERMINOLOGY

Here are those useful colour terms and what they mean:

- **Hue:** The name of a colour – red or blue, for example.
- **Value:** The lightness or darkness of a hue (also known as tone).
- **Saturation:** The intensity or purity of a hue.
- **Shade:** Colours mixed with black.
- **Tint:** Colours mixed with white.
- **Neutrals:** Greys and browns created by mixing complementary colours together (see right).
- **Colour wheel:** Circular diagram describing relationships of colours, showing the three primaries, the three secondaries and the six tertiaries (see opposite).
- **Primaries:** Red, blue and yellow. These colours are said to be the basis of all other colours.

- **Secondaries:** Pairs of primaries make the secondaries – red and blue make purple; yellow and red make orange; and yellow and blue make green.
- **Tertiaries:** Mixed pairs of one primary and one secondary, such as yellow-green, blue-purple, red-orange, and so on.
- **Analogous colours:** These lie adjacent to each other on the colour wheel and are closely related (blue, blue-green, green) as they 'flow' into one another. When used in a painting, they will create a harmonious picture.
- **Co-primaries:** Sets of different primaries extending the potential range of mixed colours, such as Lemon Yellow as opposed to Cadmium Yellow, Cerulean as opposed to Cobalt Blue, or Alizarin Crimson as opposed to Cadmium Red.
- **Complementaries:** These lie opposite each other on the colour wheel and have the least in common – they are opposites and 'clash' or push each other apart when used in a painting, creating movement and excitement.
- **Greyscale:** Gradated representation of black to white through grey values.
- **High key:** Predominantly light in value.
- **Low key:** Predominantly dark in value.
- **Monochromatic:** Range of tones within a colour range, such as light blues to dark blues through medium blues, etc.
- **Muted colour:** Softened, rich colours neutralized by using complementaries or black.
- **Anomalous colour:** A colour that breaks sharply with the tones of colours established by a group of colours, such as rich neutralized colours with one, say, bright turquoise. This will make the painting 'sing'. Look at Paul Klee's work for beautiful examples of this.
- **Optical mixing:** Dots of colours, which when viewed together make other colours. Red dots and blue dots, for example, will look like purple at a distance. The group of artist known as 'Pointillists' were known for this technique.

The colour wheel is a device used by artists, which is made up of the three primary colours (yellow, red and blue) and the three secondary colours (purple, green and orange). The wheel or circle is designed to help show how colours can be mixed together to create new colours, such as the six tertiaries (red-purple, red-orange, yellow-orange, yellow-green, blue-green and blue-purple) and also to describe some of their properties and qualities.

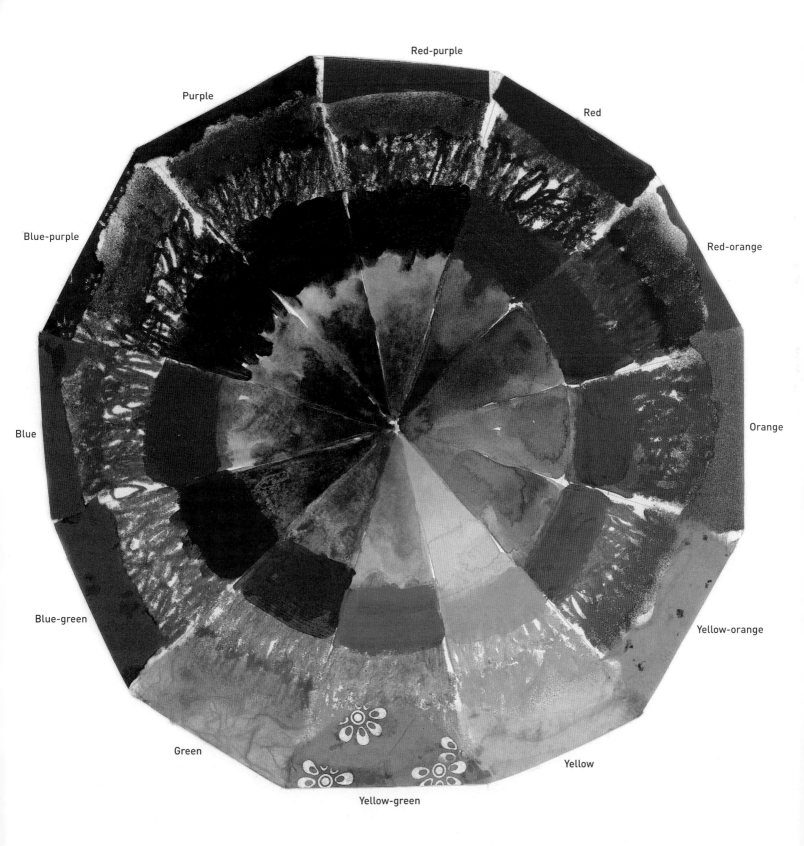

Red-purple

Purple

Red

Blue-purple

Red-orange

Blue

Orange

Blue-green

Yellow-orange

Green

Yellow

Yellow-green

MIXING COLOURS

There are some general rules to consider when you are mixing colours. Firstly, spend time mixing your colours rather than just relying on the colours in tubes, pans or sticks. By doing this, you will become more confident, and a whole new world of colour will open before you.

PRIMARY AND SECONDARY COLOURS

There are three colours with which, to all intents and purposes, all colours can be mixed. These are red, yellow and blue and they are called primary colours.

If you mix pairs of primaries, the colours you will achieve are called secondaries. Red and blue make purple; yellow and blue make green; and yellow and red make orange. Now you have six main colours, which can be shown in a circle known as a colour wheel.

TERTIARY AND COMPLEMENTARY COLOURS

If you look at my colour wheel (see page 53) you will see that there are extra colours. These are known as tertiary colours and can be mixed by adding extra colours between the primaries and secondaries. Thus if you want a more yellowy green, you could add two parts of yellow to one part blue, producing a yellow-green.

The colours on this circle have relationships, the main ones being pairs of opposites, which are known as complementary colours.

These colours are as different in their properties as they can be and are therefore seen to 'clash', pushing each other away when they are placed side by side (think of holly and berries, or poppies in a green field). This combination is very eye-catching and is often used in advertising. These pairs are red and green, yellow and purple, and blue and orange.

Primary colours: Cobalt Blue, Cadmium Red and Cadmium Yellow

Secondary colours: mix pairs of primaries to create purple, green and orange

Complementaries: blue and orange, red and green, yellow and purple are opposites on the colour wheel; they mix in pairs to produce neutrals (greys and browns)

A small quantity of complementary colour added to its partner will dull down the colour

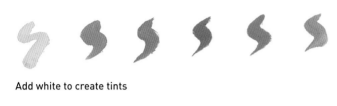

Add white to create tints

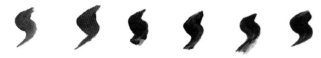

Add black to create shades

Different range of primaries: Windsor Blue,
Alizarin Crimson, Lemon Yellow

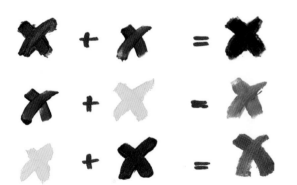

These make different sets of secondaries

And different sets of neutrals, with white added

NEUTRALS, TINTS AND SHADES

When complementary pairs are mixed they affect each other, making colours known as neutrals – greys and browns. If a little of a complementary is added to its pair, that colour will be dulled down – if a touch of red is added to a bright green, the green will become less bright. The more that is added, the duller the receiving colour will become.

Colours can also be changed by adding black or white. If you add white you will make tints. If you add black you will get shades.

COMBINATIONS OF PRIMARIES

One final, important thing: we have already seen that there are three main colours from which all colours can be mixed. In my illustration I have used Cobalt Blue, Cadmium Red and Cadmium Yellow. However, there are many different combinations of primaries, all of which will produce different colours.

In my second trio of primaries I have used Windsor Blue, Alizarin Crimson and Lemon Yellow. Look at how different the resulting secondaries are. This is because these colours have a different leaning – Lemon Yellow is slightly cold because it has a little blue in it; Alizarin Crimson is a bluey-red; and Windsor Blue a yellowy-blue. The resulting colours, therefore, all have an extra blue quality.

The quantities of reds, yellows and blues are therefore changed and combine to make very different secondaries. This brief overview of mixing colours will give you an idea about ways to produce many colours. The world of colours will be at your fingertips so go ahead, try it – you won't regret it.

PROJECT
INVESTIGATING COLOUR

Now that you have discovered how to mix and obtain many different colours, try this exercise. Cut some strips from magazine pictures, selecting strips that are not too obviously figurative. Stick these down onto paper with a space beside each one. Draw the shapes directly next to the printed ones. Now try to re-create these in different mediums to get your colours as near to the originals as possible. Some materials will reproduce colours more closely than others. Don't worry about this – just try to mix as closely as possible.

COLOUR MATCHING USING ACRYLICS

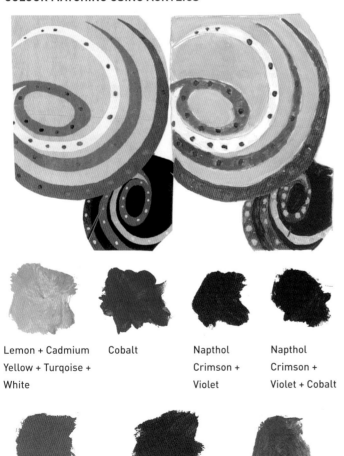

Lemon + Cadmium Yellow + Turqoise + White

Cobalt

Napthol Crimson + Violet

Napthol Crimson + Violet + Cobalt

Magenta + Violet

Crimson + Cobalt

Cobalt + Cadmium Yellow

COLOUR MATCHING USING COLOURED PENCIL

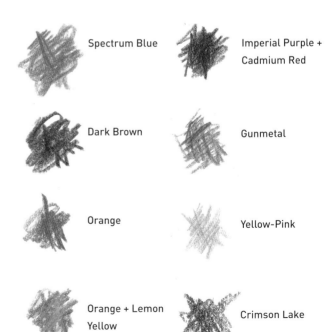

Spectrum Blue

Imperial Purple + Cadmium Red

Dark Brown

Gunmetal

Orange

Yellow-Pink

Orange + Lemon Yellow

Crimson Lake

COLOUR AND ABSTRACT

Figurative artists spend time observing their subject, whether it is a landscape, a figure or some objects, looking at the shapes and colours so as to represent the subject in as true and realistic a way as possible. Abstract artists manipulate colour on the picture plane for its own sake, using the most direct approach to colour.

However, there are many similarities in how colour can be used for both types of painters. A realistic painting is just that, a painting, and not the subject itself but a facsimile of that subject in which the shapes used can be thought of as simply a set of shapes on a picture plane, usually within a rectangle. The abstract artist also uses shapes but often they do not directly represent a 'thing'. In both cases the 'subject' should be seen to be 'living' within the confines of that rectangle and is always related to it.

So far we have looked at the properties and qualities of colour and experimented with them to see some of the visual things that happen when we mix, contrast and design with colour. But there is another important aspect of colour, which is especially useful in abstract painting, and that is its emotional and symbolic use to imply meaning, atmosphere and ideas.

COLOUR MATCHING USING WATERCOLOUR

Windsor Red +
Cadmium Yellow

Windsor Red +
Ultramarine

Ultramarine + Yellow
Ochre + White

Yellow Ochre +
Windsor Violet

Yellow Ochre + Windsor
Violet + White

Viridian +
Gold Ochre + White

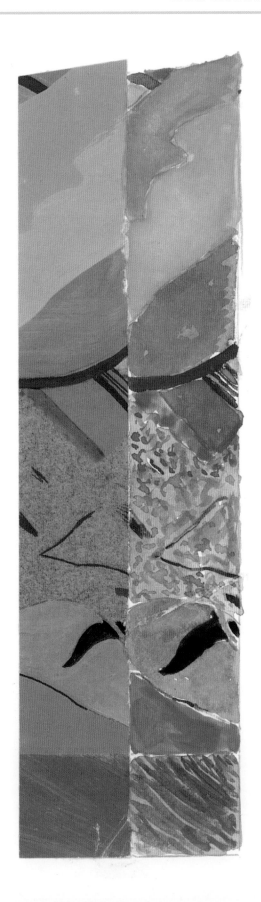

EMOTIONS, EXPRESSION AND SYMBOLISM

Artists use many devices in their paintings to express emotions and colour is one of their most powerful tools. Many colours have universal and archetypal meanings, which have evolved from different sources, such as mythology and the science of psychology. Examples of some of these are:

- **Green** signifies growth and nurturing.
- **Blue** feels sad or relaxing and contemplative.
- **Yellow** is a warm, happy colour, which can also symbolize consciousness.
- **Red** is passionate, but could mean danger.

It is known that colours affect us psychologically. For instance, soft greens are considered restful and are used to paint hospital and school walls. Light colours feel more spacious than dark ones – a room will seem bigger painted in a light yellow than a dark brown. Bright pinks and yellows are uplifting, and so on. Colours also have cultural and associative meanings. For example, they can be associated with events – red and green for Christmas; white (in western culture) for marriage or weddings; whereas purple is often seen as a 'royal' colour. You can use these associations as symbols to evoke events, atmosphere and ideas in your abstract painting.

Light brights: A hot and, perhaps, exotic place.

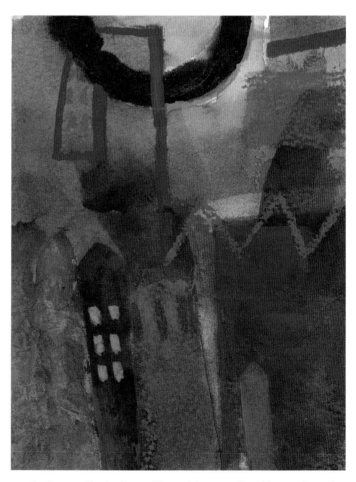

Dark neutralized colours: These rich, neutralized blues and purples suggest a mysterious place.

Harmonious colours are close to each other on the colour wheel. Here, bright yellows, oranges and orange-browns create a sunny 'rural' feel.

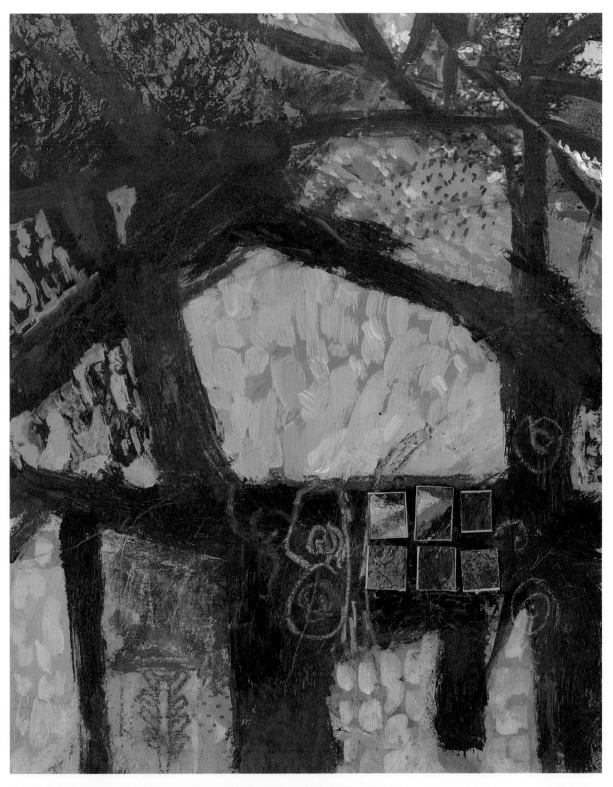

Monochromatic colours: Twilight or night-time is suggested, perhaps looking through
branches in silhouette with fading or artificial light peeping through.

Transparent colours: Here colours
are placed in transparent layers,
producing more colours as they are
'mixed' directly onto the surface.

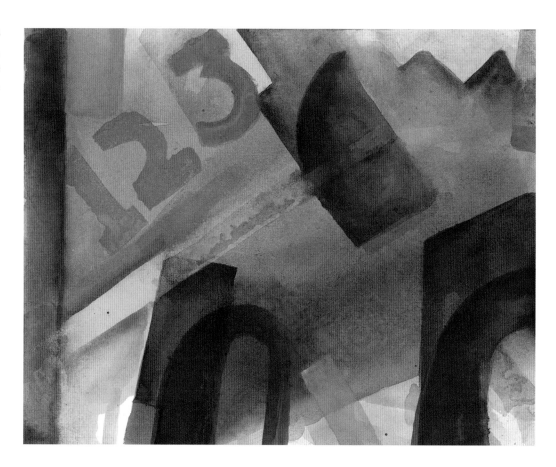

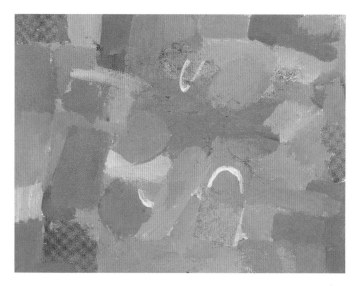

Colour anomaly: A closely related range of neutralized, tinted purples
and greys with one contradicting opposite colour – a bright, saturated,
complementary yellow – creates a painting about differences.

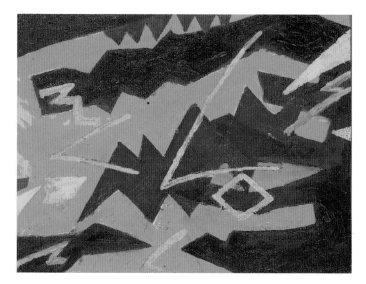

Extreme colour contrasts: Heightened contrasting colours and shapes
are used here to create a jarring effect, suggesting drama and danger.

DIFFERENT COLOUR SCHEMES

These paintings show two similar landscape compositions using different colour schemes. Notice how, by manipulating the colour palettes, the same landscape can have a very different effect on the viewer.

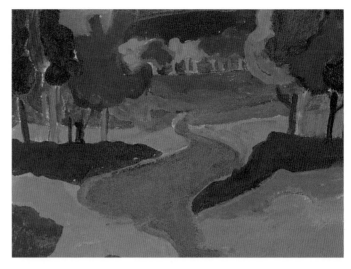

Bright, heightened colours are used with touches of complementaries, suggesting a happy, sunny, summer daylight scene.

Unrealistic, darkened but rich colours suggest a more sinister and mysterious scenario.

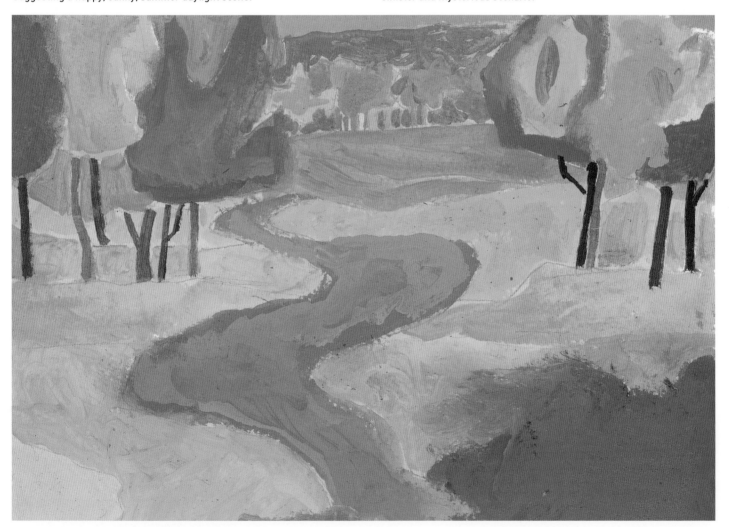

DIFFERENT INTERPRETATIONS
DAVID PRENTICE

David Prentice knows the Malvern Hills very well. He says that when he works in a particular area he wants 'to know why a landscape looks as it does'. He has an intense understanding of what he is seeing. His paintings often start off as abstracts in which he begins by playing with groups of colours that will create a sense of light – a strong element in his work. He does not often mix his colours but uses colour straight from the tube – of which he has many. The colours he uses in his work are sensual, dramatic, real and not real. They are sparkling in light areas and brooding in the dark ones. They describe wonderfully a visual and emotional experience.

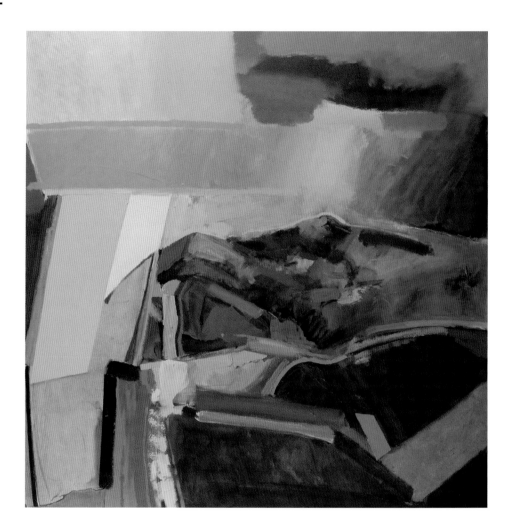

ON SUMMER HILL

Oil on canvas, 130 x 135cm (51 x 53in)

There appears to be a threatening cloud of rain in the top right of this picture – either coming or going – through which an optimistic shaft of light shines, picking out the vibrant greens, yellows and reds that describe the light as it seems to touch the hilltop. To the bottom right, the land beneath the clouds is painted in rich darks as the cloud casts its shadows.

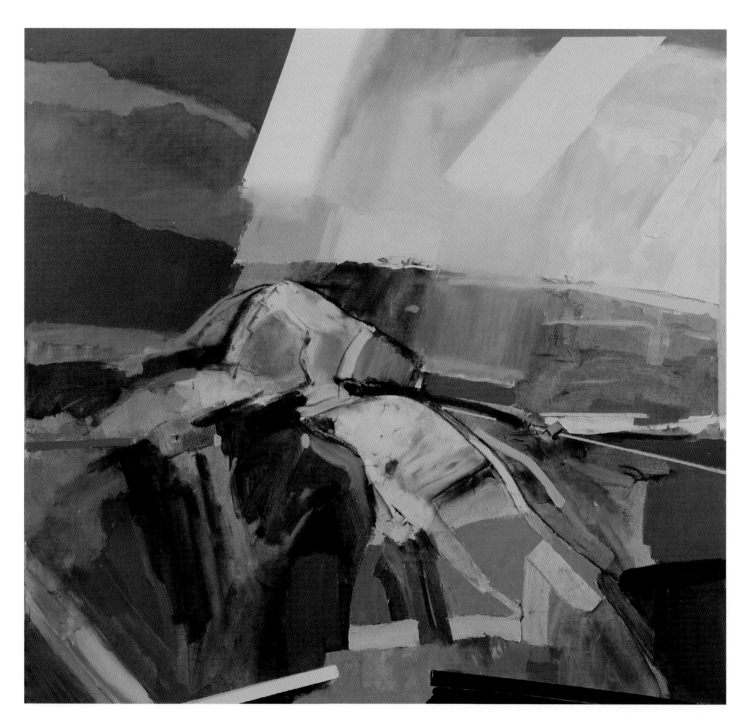

ON PERSEVERANCE

Oil on canvas, 130 x 135cm (52 x 53in)

A sense of drama is evident in this painting – the dark, moody blues, yellows and maroons to the top left threatening rain in the distance, while light floods the foreground again, highlighting the hilltops described with cream, fresh, light greens, blues and pale oranges.

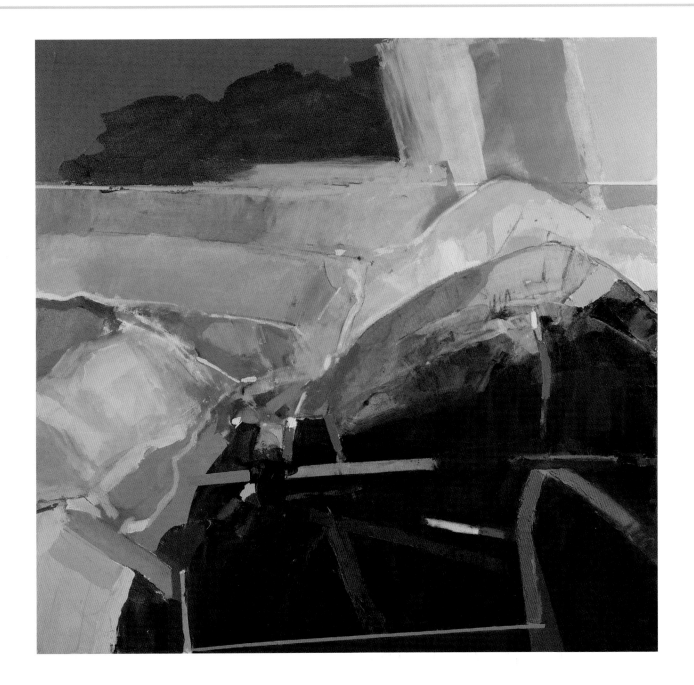

HILL SHADOW
Oil on canvas, 130 x 135cm (52 x 53in)

The bright sunshine yellows and blue skies contrast
with the deep blues and purples to the bottom right of the
painting. The brush marks are direct and lively and I love
the pink inverted V-shape 'surprise', which draws the eye
down and then points it back up again towards the sky.

BLACK HILL LIGHTFALL
Oil on canvas, 122 x 122cm (48 x 48in)

More elements of reality are shown in this piece – the big sky and
distant plains pushing the dark hills forward. The yellow mark in
the bottom right acts as an arrow, leading the eye towards the
place where, as in previous paintings, light has landed. But it is
the strokes of greens and blues and the red house roof that
encourage the eye to travel up and down over the hilltops.

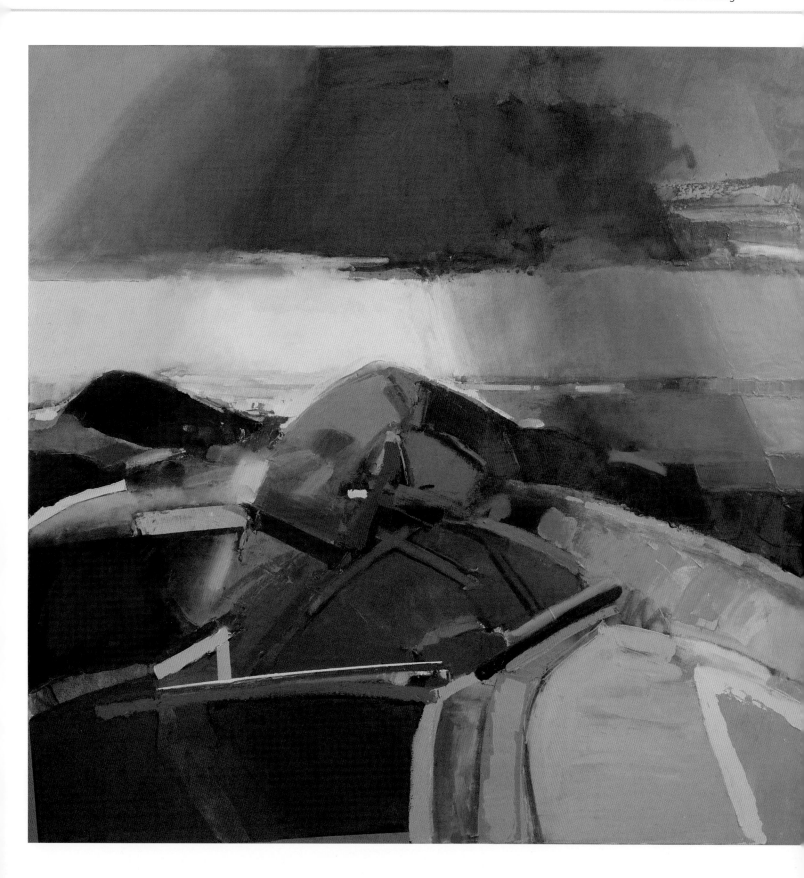

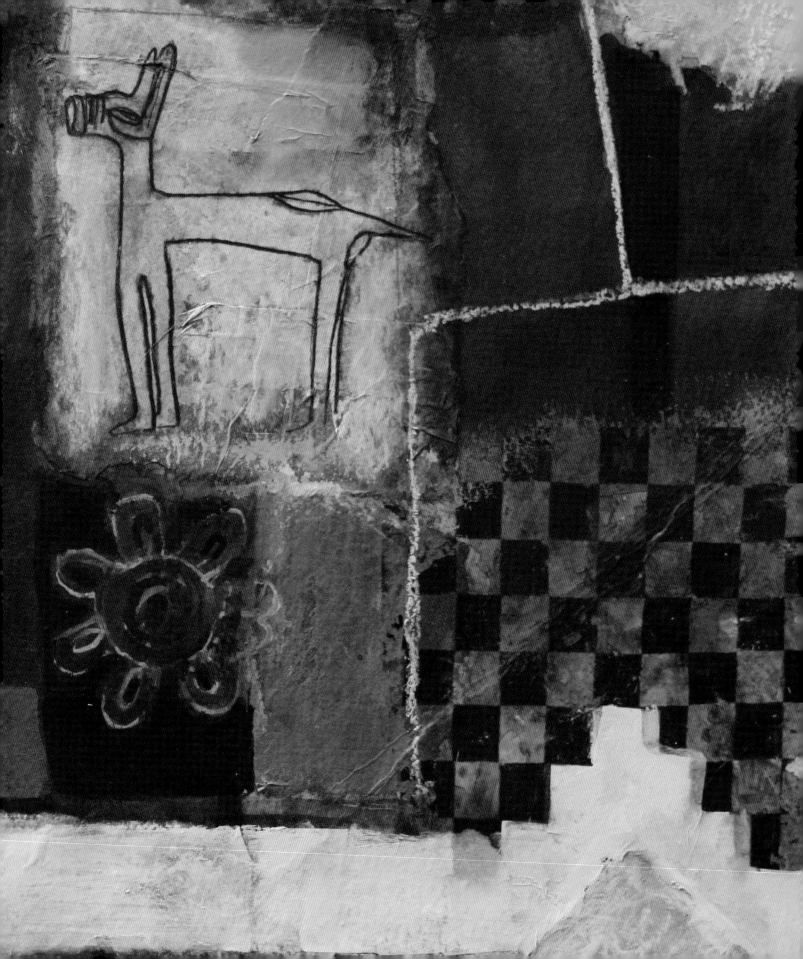

6 DESIGN AND COMPOSITION

IN THE PINK
Mixed media on paper, 60 x 48cm (24 x 19in)

The inspiration for this painting came from
a trip to Peru. The animal near the centre is
an alpaca, which is where the famous wool
comes from. I have tried to simplify it in a
primitive and symbolic manner to evoke
ancient (and modern) textile patterns.
Other elements include the wonderful
colours and motifs from Peruvian textiles
and wall carvings.

Painting a picture is one thing but making a piece of artwork say
exactly what you want – visually and emotionally – in the most
effective way requires not only the activity of putting materials
onto a piece of paper or canvas but also the organization of
these marks by way of design. When you are painting, always
take into account what each mark is doing, how it is interacting
with other marks and whether you are drawing attention to the
most important area, which describes what the painting is
about – the focal point. In short, are you tackling the difficult
question of 'composition'? This chapter is all about design and
composition: how to understand it and how to use it effectively
in order to get the best out of your ideas.

UNDERSTANDING DESIGN AND COMPOSITION

Design and composition in abstract works and stylized images are, in some ways, more straightforward than in more representational paintings since you are not distracted by the 'real'. However, even in stylized images where there is reference to the 'real' – objects, figures, landscapes, and so on – shapes can be simplified to create a good design on the picture plane while still describing something recognizable. Look at the paintings of Henri Matisse, for example.

In completely abstract images, design will rely on more nebulous elements, such as colour, line or value – think of Piet Mondrian or Mark Rothko. Much of today's ethos in painting is based on 'expression' and 'intuitive action'. Although these are very important, I think that what you need when painting any kind of picture is a mixture of these 'feeling' activities together with more intellectual, thought-based concepts.

THE ELEMENTS OF DESIGN

Designing is the intellectual side of creating an artwork, organizing the intuitive into a cohesive and exciting piece of work. To help tackle this challenge, I have set out some elements of design, which can be used to understand and resolve your paintings.

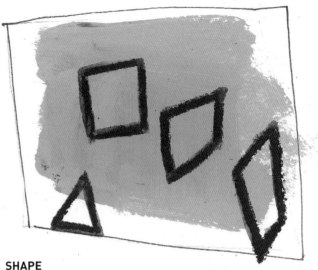

SHAPE

This is an area defined all the way around with a line. It can be filled in with tone or colour. Shapes are flat on the picture plane and are positive areas of the picture. Areas surrounding these shapes are known as negative shapes. Shapes can be evenly defined with varying dimensions, curvy or spiky. The more interesting the shapes on a picture plane the better.

LINE

The most basic mark, it can be thick, thin, straight, curved, fast, slow, jagged and so on. It can be used to define the contour of shapes, as a gesture to create texture or for decoration.

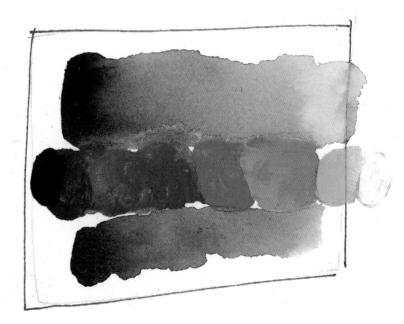

TONE OR VALUE

This is all about light and dark, from very dark to very light with all the mid-tones in between. The three-dimensional version of a shape (using tone) is a form, for example, a circle that has tone added will become a sphere. Tones help to describe distance, volume and space on the picture plane.

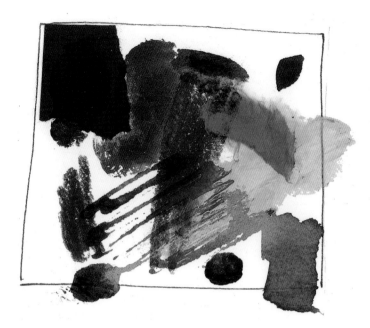

COLOUR

As we have seen on pages 50–65, colour has many properties. It will add context, interest, decoration and mood to a painting.

SIZE OR SCALE

Size is comparative and relative. In abstract art, the relationship between sizes of areas and shapes helps to give visual impact to the painting and guide the viewer's eye to its focal point.

TEXTURE AND PATTERN

Texture can be actual – applied to the surface and tangible by touch – or implied by using effects with paints, pencils and pastels and other materials, and understood through sight. It can be smooth, rough, shiny or dull. Pattern uses shapes, colours and textures either in a uniform or random way. It can add interest and decoration to a painting, but it can also help describe patterns in nature (the petals of a flower) or man-made patterns as in the bricks of a building. You can use it to create movement around your painting.

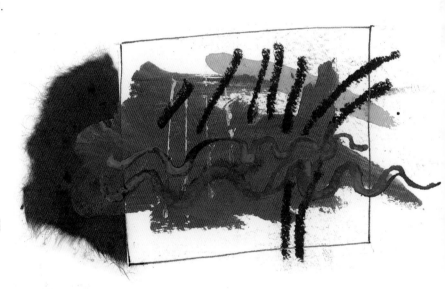

MOVEMENT

Describing movement in an abstract picture is very useful as it creates interest and can be a description of the painting itself. There are three main types of movement or direction: horizontal, which is calm and restful and can be about landscape; vertical, suggesting growth (plant forms or personal growth) and stability (buildings, figures); and oblique or diagonal, implying action (a running figure, moving vehicle or taking off for flying, all of which could be implied by using directional marks to suggest these actions).

THE PRINCIPLES OF DESIGN

The elements of design on the previous page are the visual marks that can be made on the picture plane to help describe the following principles of design.

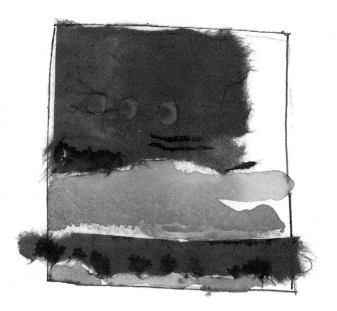

CONTRAST

Opposites can be very dynamic. They can create excitement, tension and surprise, and the resulting work will be lively and edgy. Especially with colour, opposites push and pull at the picture surface. You can use the complementary pairs to do this. We often see these contrasts in nature, man-made articles and advertising because they are eye-catching. Other contrasts include large and small, bright and dull, curved and straight.

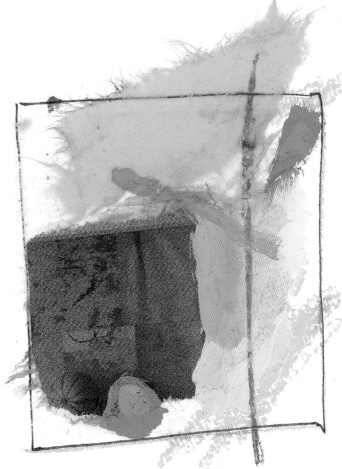

HARMONY

When a picture has colours that are adjacent on the colour wheel, or when it has close values and similarities in line, scale and shapes, it will feel harmonious and be comfortable and pleasing to look at. To enliven a harmonious painting, a subtle variation of these close elements can be employed such as a slightly brighter colour or some heavier lines, or a strange, perhaps wobbly horizon line.

GRADATION

A series of small steps, say, from light to dark, thick to thin, or small to large. One of the easiest methods of graduation is to gradually change the initial colour by adding white bit by bit until it is just white with a hint of the initial hue. It is a slower way to travel around a picture, gradually leading the viewer's eye to the next designated stop. If gradation moves in all directions at once, it is known as radiation.

DOMINANCE

The dominant design element is what your picture is all about. One shape may be repeated two or more times, one piece might be bigger than another, or one colour brighter or stronger than others. If elements are fighting with each other for importance, the picture is not resolved because its subject is not clear.

BALANCE

A very important principle in the design of a painting, balance refers to the distribution of elements to provide equilibrium, whether symmetrical (equal elements presented with an even weight on both sides of a central point) or asymmetrical (where elements are unevenly divided but still balanced according to visual weight). It is difficult performing this balancing act but the more familiar you become with the 'feel' of a painting and its balances and counterbalance, the more you will be able to adjust accordingly.

REPETITION AND RHYTHM

Our eyes search for visual clues to help guide us around a painting, and the artist's job is to provide the best ones possible in the progression of the work. One way to do this is by repetition – repeating colours, tones, shapes, textures, and the size and direction of lines. They act like echoes within the world of the rectangle in which they live. Rhythm is another form of repetition. It is often created with marks made fairly close to each other, allowing the eye to 'dance' across the painting, either at even intervals or at uneven ones but nevertheless recognizably related as a set of steps.

UNITY

The final important aspect to take into account in every piece of work is unity. Several elements will undoubtedly be involved in your design, which will, at times, conflict and fight with each other for importance. These conflicts must be resolved in order to create the unity of the whole. This is the single most important aspect in the making of a picture. Until unity and a sense of completeness are achieved, the painting is not finished. It is often 'felt' before it is intellectually understood.

COMPOSITIONAL DESIGN FORMATS

A painting requires a strong composition for it to work successfully. There are some basic shapes that artists can use, known as compositional design formats or shapes. Some of these shapes are illustrated here with examples of finished pieces of work alongside.

DIAGONAL OR TRIANGLE

A diagonal format suggests movement and excitement. Several diagonals can be used in a painting but always make sure that they do not make the viewer's eye wander out of the painting. A strategically placed element will be needed to bring the viewer back into the painting. Upward triangles suggest optimism whereas downward ones can feel like 'falling' (see painting, page 76).

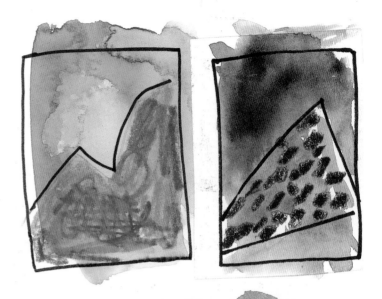

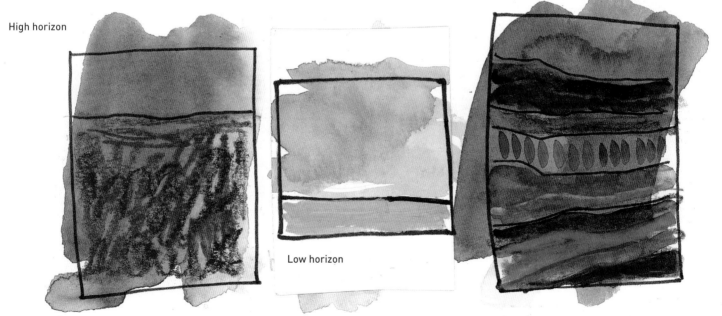

High horizon

Low horizon

HIGH HORIZON/LOW HORIZON

A tall vertical give a sense of height as in high buildings or mountains, while a high horizon implies vastness and space. A short vertical brings the eye to the focal point, allowing it to rest in the vast areas surrounding it while a low horizontal is restful, 'grounding' the subject and containing interest within a wide focal point (see painting, page 76).

STRATA

This format literally means 'stripes' and divides the painting into strips of varying widths. It can imply landscape and its layers both above and below the earth, but, as with all design formats, it can act as a metaphor for more cerebral ideas. In this case it could be a metaphor for, say, life existing as a series of layers (see painting, page 77).

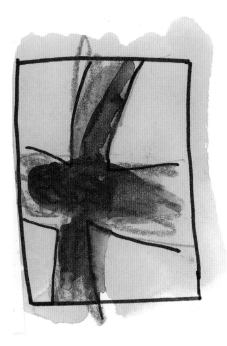

CRUCIFORM

As the name suggests, this composition has a cross format. The centre of interest in this kind of painting is in the intersection of the cross. This intersection can be high or low, or central or to one side. The eye is led upwards and outwards and the cross holds onto the edges of the rectangle, giving the painting a feeling of stability.

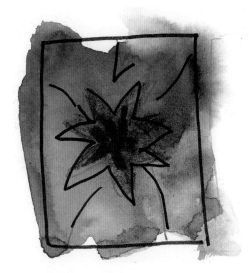

CENTRAL ORIENTATION

The focal point is right in the middle of the painting. The danger in using this format is that it can be boring if you are not careful. Variety in other elements of the painting and not too obvious symmetry are essential to keep the viewer interested.

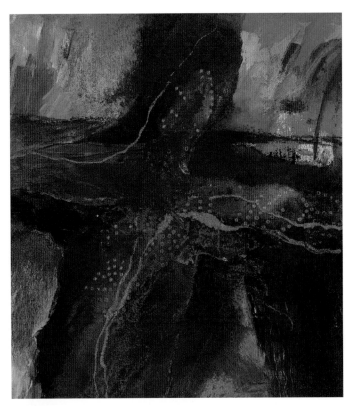

'HORIZON'
Strong central cross shape (cruciform)

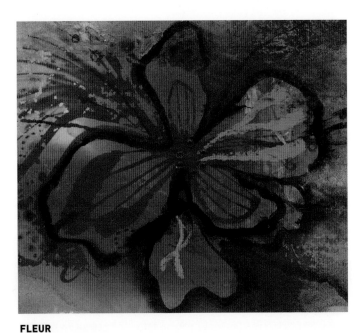

FLEUR
Central orientation

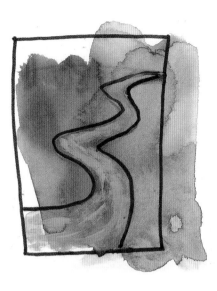

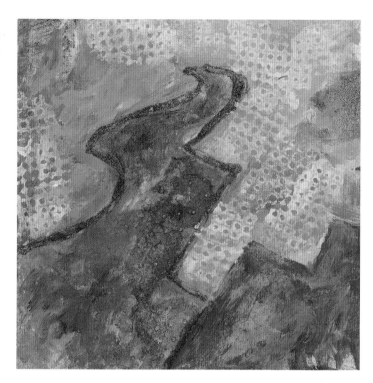

FROM ABOVE
'S' or 'Z' curve

'S' OR 'Z' CURVE

This format leads the eye dynamically into the painting. A jagged or sharp shape can be dramatic and urgent. If it is soft and undulating, the eye's journey into the painting will be gentle and gradual.

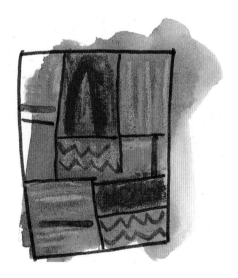

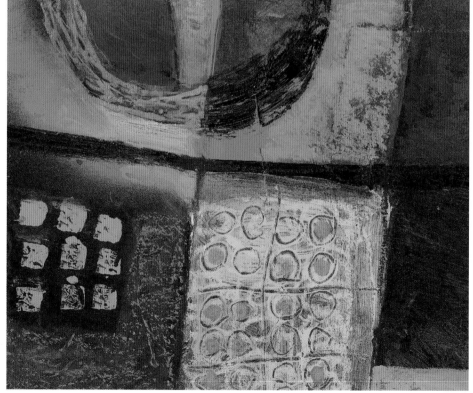

GRID FORMAT

As implied, a painting using the grid format uses squares as compositional divisions. These can be even or uneven, outlined or divided by colour, tone or texture, or they can be about the squares themselves. These rectangles can also be used as areas of containment for symbols and a more narrative subject matter.

CIRCULAR SQUARE
Grid format

OVERALL PATTERNING

This is one of my favourite shapes. It can be tricky to resolve but I always find it an exciting challenge. Although there is no distinct focal point in this format, you must make it clear what you want the viewers to look at and guide their eyes accordingly. It is a kind of weaving activity, each mark and shape responding to the last until there is unity and balance without uniformity.

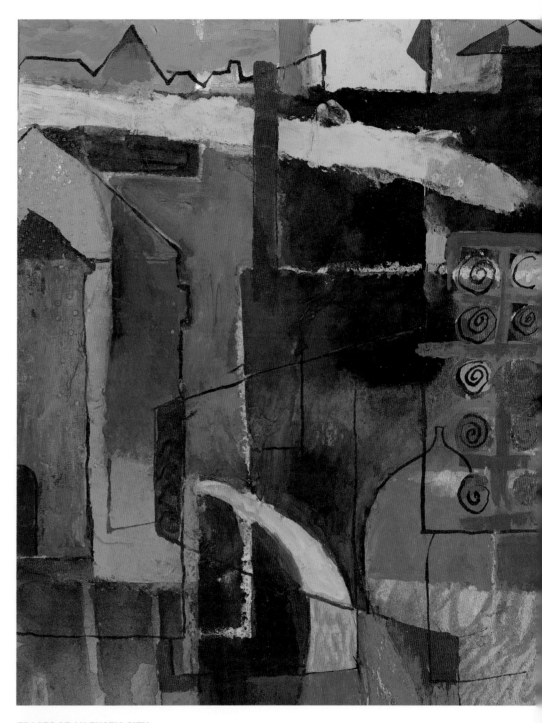

TRACES OF AN EXOTIC CITY
Overall patterning

GETTING THE BEST OUT OF YOUR COMPOSITION

When you are in the process of composing and painting, you should think about the following points. They will help you to get the best out of your composition.

- Where or what is the focal point? The viewer's eye should be drawn to this – it is the most important part of the painting.
- Always keep an eye on the rectangle. Your painting 'lives' within it and must always relate to its confines.
- Have you got a variety of tones and\or colours?
- Think about your elements and principles – check that you have a variety of these involved and that they are all doing a job within the painting.
- Have you got both busy and quiet areas? The viewer's eye needs places to rest in the painting as well as to be stimulated.
- Have you achieved the overall 'feeling' you want to convey? Abstract paintings especially often need to express the importance of less tangible things.
- Finally, is there unity in your painting? Are there any more questions to be answered (every mark in a composition asks a question that needs a response elsewhere in the painting). When there are no more answers to be found your painting is finished.

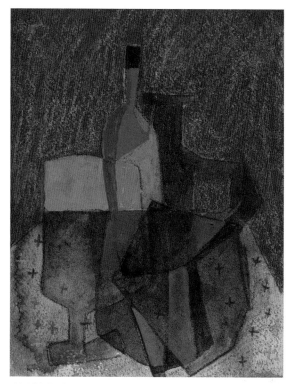

GLASS GROUP
Triangular

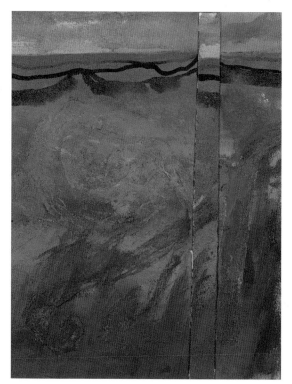

SEA SWIRL
High horizon

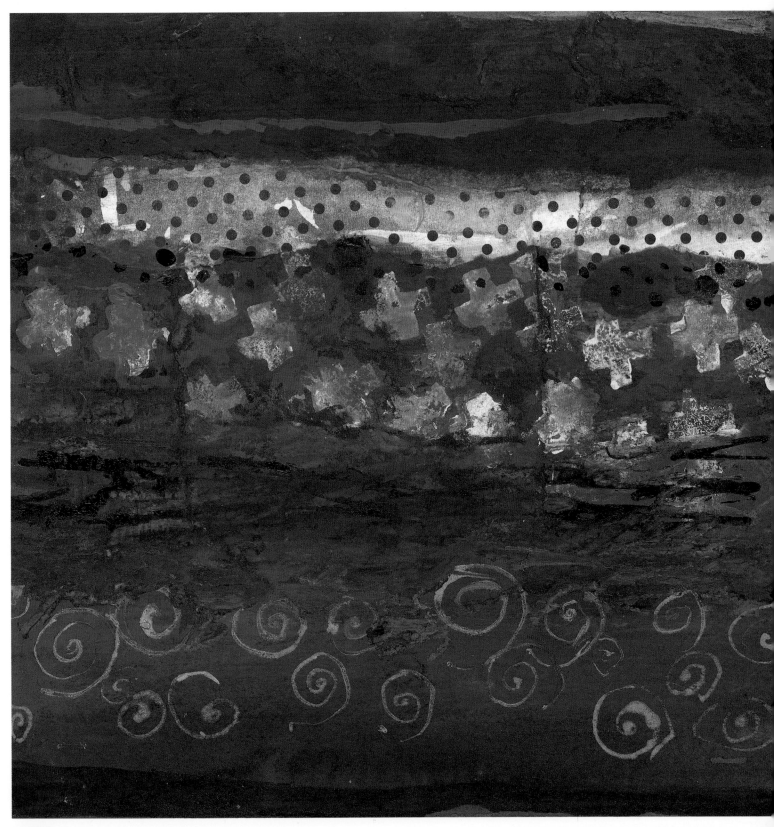

LAYERS
Strata

PROJECT
USING CUT-UP PHOTOS

This project illustrates a way to organize your composition using cut-up photos. Composition can be difficult for, as we have seen, there are so many things to take into consideration. One way is to do some preliminary drawings in your sketchbook, looking at your subject, whether it is real and in front of you, taken from photographs or extracted from your mind.

The following project provides you with something concrete to hold on to. You will still be composing and although there is no substitute for drawing, this can be a starting point for a strong painting. First, decide if you want to paint an abstracted picture about a particular subject. I have chosen my visit to Marrakech in Morocco, but you could choose random photographs and see what arises.

Collage using cut-up photos Tracing – enlarged in Photoshop

PHOTOS
You are going to use your own photos, so make sure you are not cutting any up that you could not retrieve if you needed them again. Alternatively, print your images onto printing paper from your computer, or get some colour photocopies. I have used the original photos.

POSITIONING AND COMPOSING
Begin to compose, 'drawing' with the cut-up pieces of photo. Make the same considerations as if you were painting. You can end up with strong grids (as I have) but if you want to avoid this happening, try tearing the edges. Use repetition of colours, shape and pattern to help guide your eye around the page. Don't stick the pieces down until you are happy with the result. You have made a montage.

TRANSFERRING
The next thing to do is to trace this image using only line. Trace as many shapes as you can, including shapes of shadows and so on. When you have done this, make the tracing as big as you would like the picture to be. The best way to do this is to make a photocopy in a bigger format, or scan it into your computer, enlarge it and then print it. From this, you can re-trace the bigger image and then transfer it onto your paper. At any stage, if you prefer and are confident enough, you could draw your

image freehand. As you get better at doing this you will be able, if you prefer, to keep things a little bit looser.

READY TO PAINT
Now you are ready to begin painting. Don't be afraid to use the materials you have found out about in previous chapters. You have decided on your basic composition and that will leave you free to experiment. Keep re-assessing your progress, so that you are not just filling in shapes like a jigsaw, and only place colours and marks where they really help the composition. Don't be afraid to leave out lines and areas that don't seem important, making these areas quieter ones.

MARRAKECH COURTYARD
My finished painting bears many similarities to the original but I have changed the colours considerably, using them to create a pinky-red, low cruciform shape, surrounded essentially by variations of green. Shapes and forms appear within these basic shapes. To finish, I have used yellow to paint the small cross shape on the left-hand side, adding beads to highlight it from the rest of the painting and emphasizing the 'cross' idea of the cruciform shape.

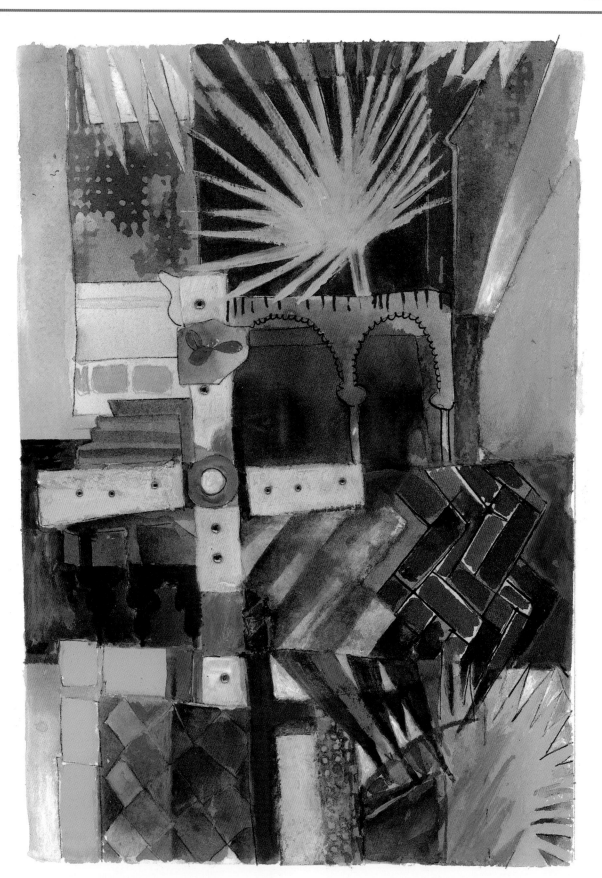

MARRAKECH COURTYARD
Mixed media on paper,
24 x 34cm (9½ x 13in)

This painting was
composed from a collection
of photographs, which were
resolved into a painting
by tracing the shapes and
lines, changing the colours
and emphasizing the
cruciform shape.

DIFFERENT INTERPRETATIONS
CLAIRE HARRIGAN

Claire Harrigan's work is a visual feast of colour and light. She uses colour to express her thoughts and feelings about a particular subject that has caught her eye. Her responses and feelings about a subject are further enhanced if there is a 'particular quality of light'. Furthermore, she seems to use colour to perfect effect as a compositional tool, guiding the viewer's eye around her paintings. Although the pictures have recognizable elements, she simplifies, stylizes and distorts them, so that shapes often work like a multi-faceted jewel across the surface. Her uncompromising way of assembling all these shapes together leads to stunning results.

THE TRAPEZE
Acrylic, pastel and oil pastel on paper, 69 x 96.5cm (27 x 38in)

The spotlight on the trapeze artists in this painting not only portrays the way in which performers are lit, but it also metaphorically spotlights the focal point of the painting. The movement of figures describes an elegant curve, contrasting with the dark stillness beyond the spotlight where one can almost feel the audience holding their breath with anticipation. Drama is created with extreme contrast in tone.

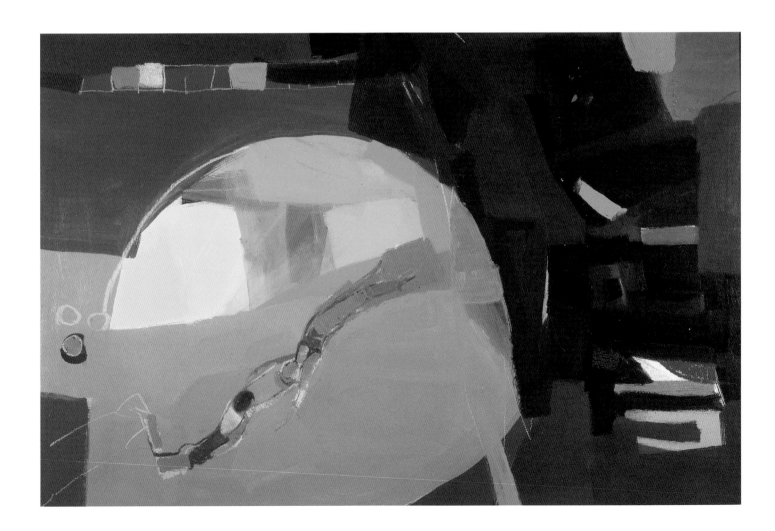

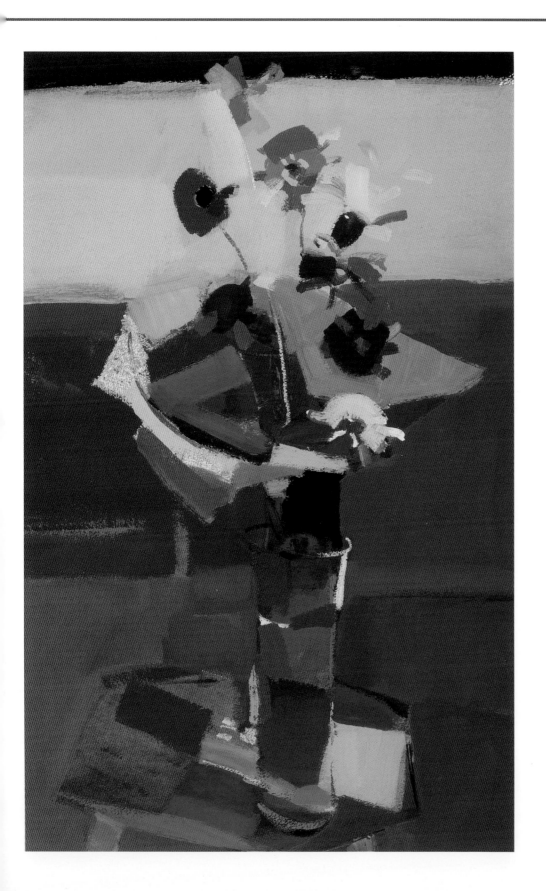

JULY FLOWERS

Acrylic and oil pastel on paper,
53 x 35.5cm (21 x 14in)

The vibrant colours, together with
the bold, central vertical shape of
the vase and flowers, make a very
dynamic and exciting painting. The
eye is carried upwards through the
painting with 'arrows' of reds, pinks
and oranges and back down again
from the yellow background down
to the yellow highlight on the vase.

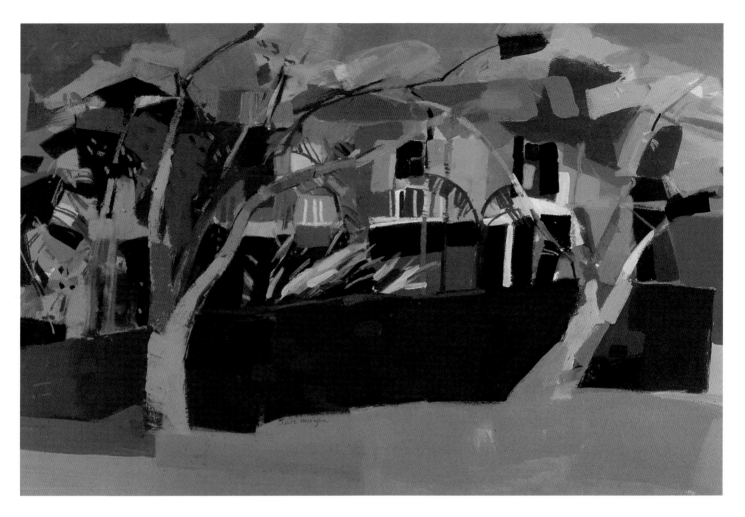

MONTPELLIER
Acrylic and oil pastel on paper, 61 x 96.5cm (24 x 38in)

The greens and yellows on the ground and trees lead us in a semi-circle
around this painting that, where the two branches meet to create this
semi-circle, also acts as a kind of archway through which
we can see a building a small distance away. The lightness of the tree
trunks and the essentially darker areas of blues and turquoises give
us a sense of space on the picture plane, although this space is fairly
shallow as the tones are not too distant from each other.

BANANA SELLERS
Acrylic ink, gouache and oil pastel on paper, 76 x 56cm (30 x 22in)

The two banana sellers, the tree and its branches have somehow
created a rectangle at a slight angle in the centre of the painting,
which is echoed by the direct, rectangular brush marks used to
describe the tree and leaves. The colours are warm and rather sultry
and there is a charming interaction going on between the figures.

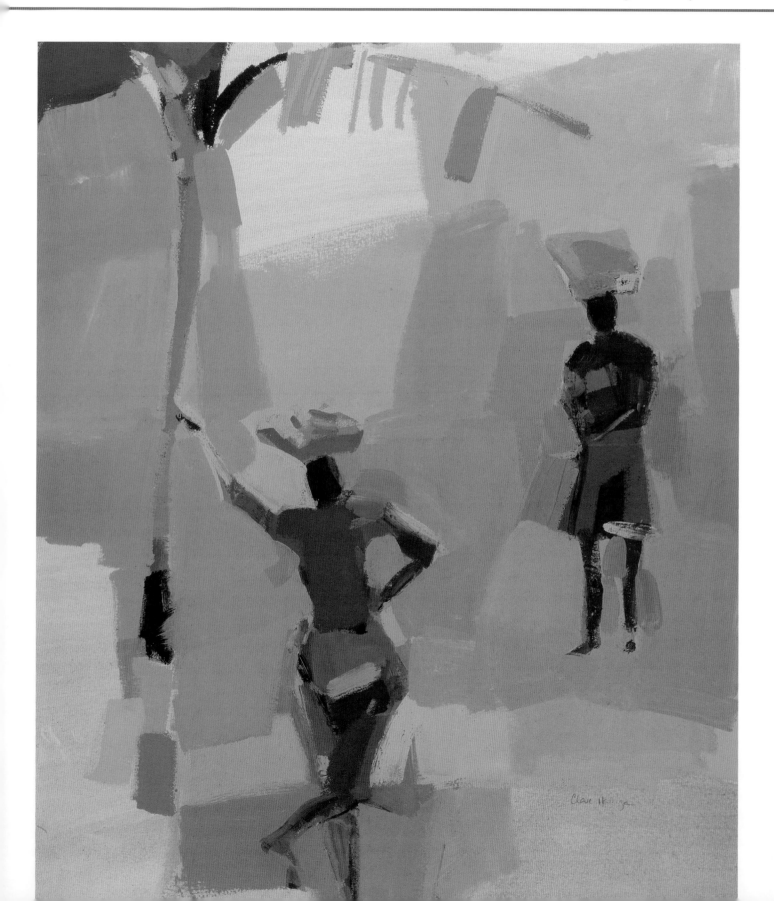

7 SOURCES OF INSPIRATION

Finding sources of inspiration and subject matter for painting is not always easy, especially when working with abstracts, but it can be found all around us – it just needs a little thought, a way of really looking and seeing, and some solid research. Why not keep a visual diary – a sketchbook or journal – where all ideas, notes, drawings and printed bits of inspiration can be easily accessed? You can make this 'diary' an ongoing and important part of your artistic life. Abstraction can come from 'real' or imagined things. Different types of subject matter can inspire you, including real, natural and man-made forms and the human form as well as your imagination, emotions and experience – the following pages will guide you.

FABRICS AND FEATHERS, LA PAZ
Mixed media on paper, 51 x 51cm (20 x 20in)

I visited an amazing textile and feather museum in La Paz, Bolivia. There were fabric pieces from ancient times to the present and, in one room, there were magnificent 'sculptures' consisting of many coloured feathers enclosed in glass cases. These, the patterned textiles, the view through the glass cases and the reflections on glass were the inspiration for this painting.

NATURAL FORMS

This selection of images describes some of the real things from which abstraction can derive. There are many types of natural form, which are found in a variety of locations and situations, such as water or landscape.

Within both these categories you can capture organic effects, such as reflections, shadows, silhouettes and colour, pattern and texture, as well as the 'whole' form, all of which are abstract in their own right.

WATER
This includes the sea, underneath and from a distance, as well as rivers, waterfalls and ponds. Look for shells and fossils, fishes and other water creatures.

LANDSCAPE
Included in this category are trees, leaves, flowers and plants, as well as the sky – clouds, the weather, lightning, snow – and mountains. Collect fir cones and leaves for inspiration.

Flowers

Reflections of boats

Waterfall – Iguazu Falls, on the border of Brazil and Argentina

Glacier – Chamonix

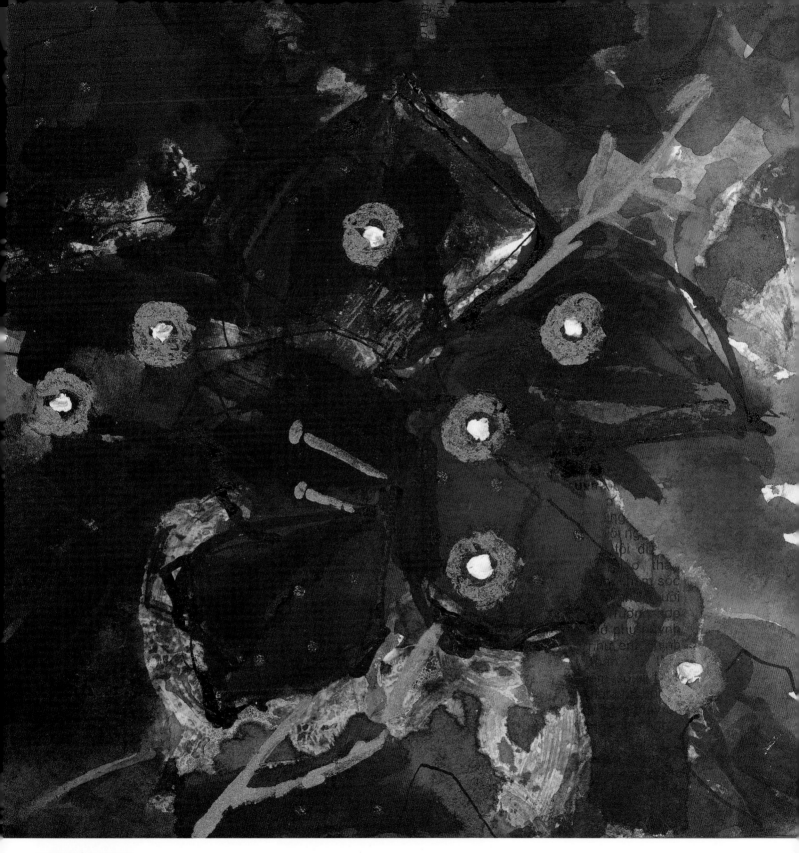

CRIMSON AND GOLD

I have cropped the original photograph (above left) to create a square format. I have made a feature
of the little white flowers by simplifying them, painting them gold and adding white circles.

MAN-MADE FORMS

Keep your eyes open wherever you go – inspiration will be there if only you can notice it. Even seemingly nondescript buildings and everyday objects can become a source of inspiration for your paintings.

BUILDINGS AND ARCHITECTURE

This group includes complete or close-up glimpses of single buildings or streets. They can be ancient or modern, large or small. Pick out doors, windows, columns and roofs. Look at bridges and garden structures.

SMALL MAN-MADE OBJECTS

This group features such things as marbles, jewellery and ornaments, buttons and other haberdashery items. Glass objects offer transparency and distortion. Soft objects, such as fabrics, clothing and hats, show folds and curvy, malleable structures.

EVERYDAY OBJECTS

Kitchen utensils and office materials, such as paper clips or pens and pencils, fall within this group. Also featured are larger objects,

Deckchairs

such as the wheels on a car or bicycle. Look under the bonnet of a car, at the workings inside a clock or other machinery, as well as at scaffolding and metal tubing. Look in tool boxes – they contain a jumble of wonderful shapes and textures. Go further afield to find piles of fishing nets, wire netting, iron grating or cast-iron gates. Visit railway yards and canals which house colourful barges.

Pink fishing nets

Wall painting in Pompeii

Graffiti in Verona

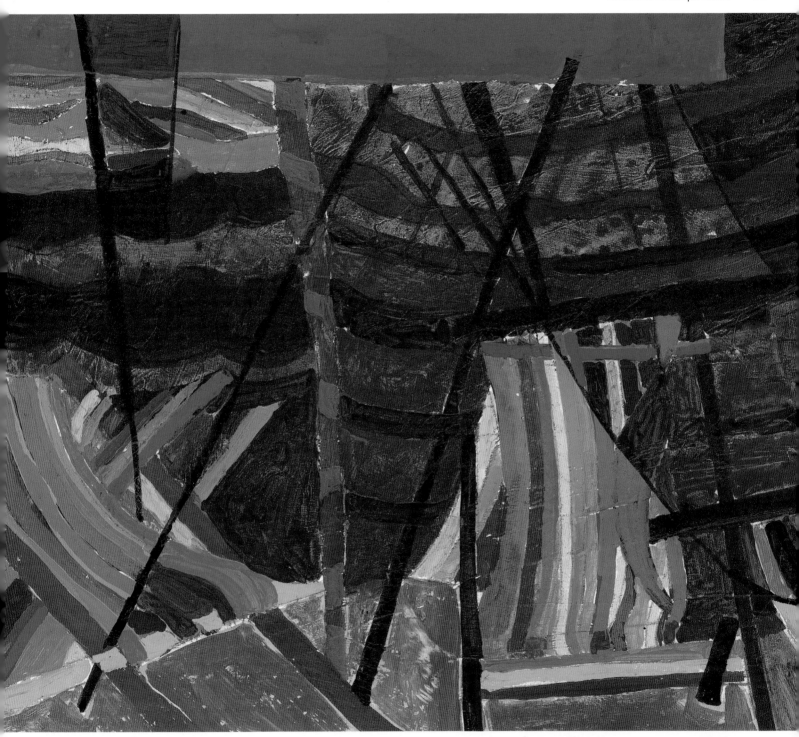

STRIPES

The striped deckchairs in the photograph (above left) sitting in front of more stripes on the wind breaker, made me see an interplay of strips of colour, all at different angles. In the painting I have tried to create a sense of abstracted movement while still not entirely losing the deckchairs themselves.

MUSEUMS

There are museums in cities and towns all over the world. If you have access to one, you will find a huge selection of possible subjects for painting in mixed media and the abstract. These include ancient statues and artefacts and natural forms from less accessible and exotic places. You can also visit more specialized establishments, such as garden or transport museums.

The settings and surroundings in museums are especially useful for composition, with reflected images in glass cases, supports and shadows. As well as drawing in your sketchbook, you can purchase postcards and leaflets, which can inform your paintings when you get back to work in your studio.

USING PHOTOGRAPHIC REFERENCE

One of the most useful ways of gathering information is to take some photographs. Digital cameras are easy to use and printing the photos you take is cheap and simple. And you will always have a record of your photos logged in your computer ready for use if you need them in the future. Particularly useful if you are short of time to draw, this is a good way of capturing memories of places visited and subjects seen.

Many of my own paintings are of exciting places I have visited. Because I often don't have enough time between locations, I always make sure that I take a lot of photographs. When I return home, the first thing I do is prepare what I call a 'memory board' (see pages 98–99). To do this, I sift and sort the images into groups – often from each particular location – before selecting some and sticking them onto an A1 board. The overview I get helps me to recapture the feelings and responses I experienced while away. I place them around me in my studio before I start to work.

Feathered objects in a museum in La Paz, Bolivia

Gold figures from Peru

Golden bowl

KIMONOS

I loved this photograph (left) taken in a London museum. Not just for the subject – the kimonos themselves – but for the reflections that seem to emphasize the rectangle-ness of the shapes. I have used transparent layers of colour to give a sense of the objects themselves and also of the shapes in the shiny glass.

Kimonos behind glass

THE HUMAN FORM

Even if you are not interested in people themselves as subject matter, images of the figure can be found in many different forms. These might include statues, masks, ornaments, decorations on tiles or textiles and so on.

Now take a look at some of my examples of these different subjects. Although they are just a few of the many possibilities, they can give you ideas about what might make interesting abstracted pictures. These examples are photo references, but, as I have already stated, you should always try to back up these photos with drawings and other forms of reference.

Indian scene

Venetian carnival mask

Peruvian mother and baby

Stone angel in Buenos Aires cemetery

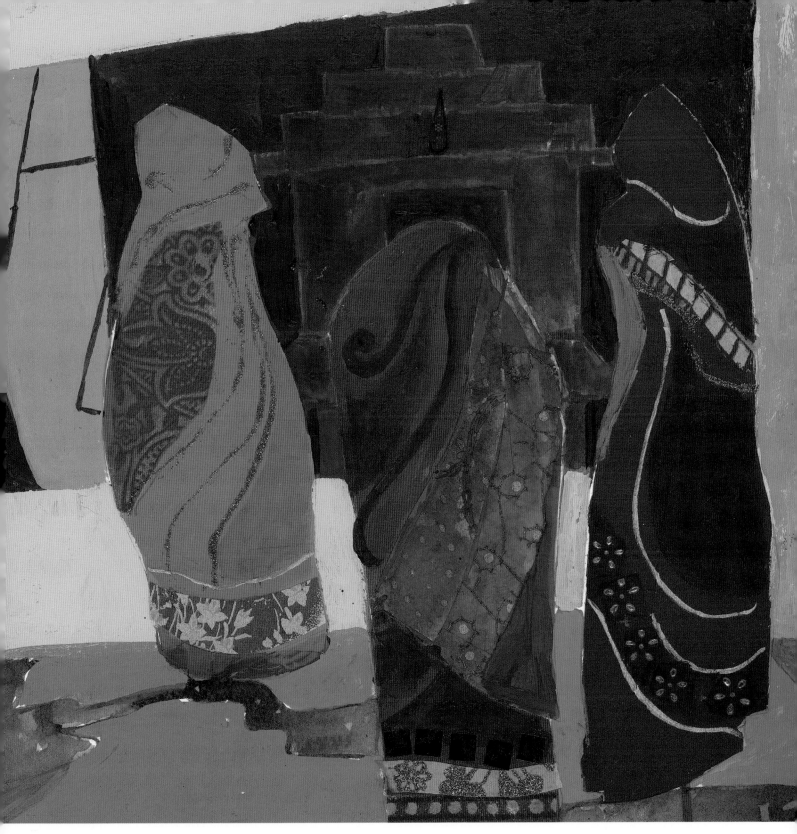

INDIAN LADIES

One of the most eye-catching sights in India is the vibrant colours of the ladies in their saris. The back view of these women (above left) creates solid flashes of colour emphasized by a rather neutral backdrop, which I have tried to capture in the painting above.

PROJECT
BEGINNING WITH MARKS

Working from within means letting go of any preconceived idea as to what the picture might end up like. It is an exciting way to work as long as you are prepared to be experimental and adventurous. If you can do this, the results can be beautiful, personal, surprising and extremely satisfying. My example will give you ideas about how to go about this initially, but you will soon find your own marks, colours and shapes as you develop your own work.

Start off by assembling a variety of materials: paints, pastels, pencils, collage materials, texture gels, and so on. Have them at your fingertips so that you can pick them up as spontaneously as possible. Perhaps play some favourite music so that you can create as conducive an atmosphere as possible for the job in hand. Take your paper, take a deep breath ... and begin.

MIX SOME PAINT

Start by mixing some watery paint (watercolour or acrylic). Wet your paper and fill your brush with paint. Drop paint onto the wet area and wiggle the paper around, so that the paint flows in different directions. This is called working wet into wet.

CREATE LINES

When this has dried, create some lines with a dry material – pastel, pen or crayon. Make sure some of these lines touch the edge of the paper and that some shapes are formed.

FILL IN SHAPES

Begin to fill in some of those shapes with other colours, patterns and materials. Continue to add to the work. Select marks, shapes and placements carefully but try not to decide what this painting is about yet.

Wet-into-wet wash with watercolour.

Create lines with oil pastels and pencil.

Fill in with colours to create shapes.

INTRODUCE MARKS AND PATTERNS

Now that you have established the 'bones' of the composition, you can begin to have more fun with additional materials and methods for mark making. In my example I have continued by adding pattern in three different ways:

- Simple crosses drawn with coloured pencil, which follow one of the initial lines and emphasize an upward and diagonal movement in the top half of the picture.
- A 'spotty' strip cut from some wrapping paper along the left-hand side, which has been collaged onto the painting.
- Stamped squares. I made a small, square stamp using Funky Foam then printed a group of six squares on the bottom right using acrylic paint.

Of course, you can add as many other marks and materials as you like. Try to stay experimental and free.

CREATE DEPTH WITH TONE

To create a sense of space or depth in the composition begin to develop some darker areas. Dark, dull areas tend to recede into the picture plane, sending light or bright areas forward. A good way to do this is to paint wet-into-wet areas of watercolour into certain areas. I have used a red-brown wash from the 'crosses' area in a triangular shape down to the bottom of the page. The more you repeat these washes the darker the area will become, making a greater tonal contrast between the spaces in the front of the painting and those further back.

CHOOSE A TITLE

Up until this point the painting is in some ways painting itself. Marks are being applied in an organic way – one from the other. Now it is time to decide what your painting is about. Take time to look at your painting so far. Ask yourself some questions: What do the colours suggest? What do the patterns and shapes remind you of? Are words coming to mind as you look? Turn the painting around and see if by doing this a subject becomes clearer. Now decide on a title – as specific or as loose as you like. The idea is to give you a 'hook' on which to hang future marks, colours and textures, working towards a successful and balanced outcome.

I decided to call my painting 'Wigwam' as it was beginning to remind me of American Indian colours and markings. However, your painting does not necessarily have to end up representing something as concrete as this – it may feel like an atmosphere or it might seem to be saying something about the music you are playing. The main thing is that it feels connected to an idea, place, thing or experience. By finding a title during the process you will be able to focus on your painting and steer it towards that subject. This way, communicating the idea to your viewer is likely to more successful.

Introduce marks and patterns using simple printing, coloured pencil and collage.

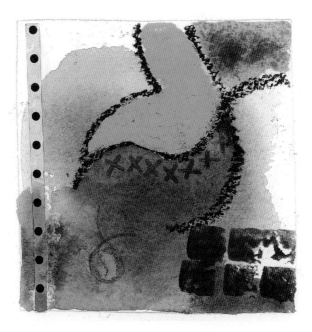

Create depth with tone.

FINISH THE PAINTING

The final stages of my painting involve:

- Repetition – I have drawn large and small zigzags in blue paint in various areas to create repetition, which is one way of allowing the eye to be guided around the painting. Remember the principles of design described on pages 70–71 and use these to help the design of your painting.
- At this stage I have used silver lines which sit on the surface as they are metallic and create some movement.
- Next I applied some texture gel (natural sand) – one curved line which echoes some of the silver ones, and the other a curved triangle. As soon as you add more texture to the surface, you add another physical dimension to the painting. When the gel had dried it was painted with a purply blue colour. The shapes sit above others and imply a new space on the picture plane.

FINISHING TOUCHES

My painting is nearly finished. Having decided that the title would be 'Wigwam' earlier I have now decided to insert, among the previous marks, a wigwam shape. I have placed this shape so that many of the previous shapes are surrounding it, curving and swirling around, almost pointing to the 'star of the show'. A few more marks and colours to enhance this idea – some blue stripes to the right and a strong red area top right, and one or two more patterns within the wigwam – and the painting is finished.

HOW DO I KNOW IF A PAINTING IS FINISHED?

I am often being asked this question. As I have mentioned in the chapter on design and composition, every mark you make is a question that needs to be answered elsewhere in the painting. My general rule is that when there don't seem to be any more questions to answer the painting is finished. However, the arrival at the end of a painting will also be an intuitive thing, and the more you paint the more you will begin to get the feel for this.

Finally, beginning with marks to make a painting can feel risky and difficult, but as long as you keep an open mind, enjoy your materials and put passion into the work, you will surely be on the way to painting exciting abstracted images.

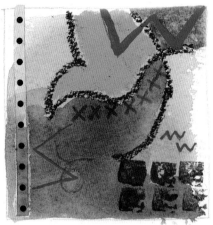

Large zigzags are drawn with blue paint, then smaller zigzags are added for repetition.

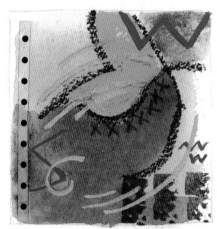

Silver lines are used to create and emphasize movement.

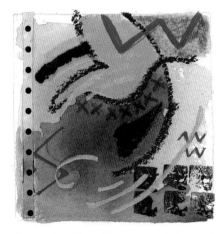

Texture is added with texture gels (natural sand) painted with Ultramarine Blue acrylic paint, lifting some areas above the main surface.

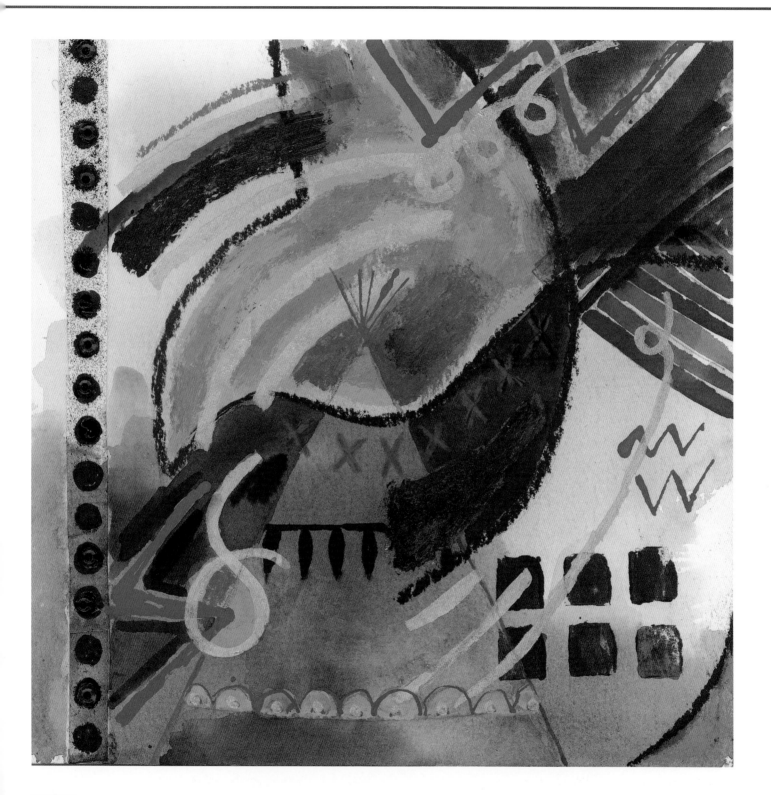

WIGWAM

The finished painting. A wigwam shape has been added, together with
more patterns, to reinforce the theme of Indian American culture.

KEEPING A VISUAL DIARY

- Have a sketchbook/journal with you whenever it is possible to do so.
- Look for useful images in magazines or on the internet and paste them into your book – these can be ideas for colours or textures, images you are excited by, and subject matter you are interested in. You can also stick in postcards of artwork you have seen in galleries and of artists you admire and who inspire you.
- Draw and paint in your sketchbook. It is the most private place you have to do this and no-one else needs to see it.

- Take photos of anything that visually interests you (easy to do nowadays with digital technology).
- Try out techniques and look for new materials.
- Use yourself as subject matter – make notes of your thoughts and ideas, even your day-to-day life.
- Visit art galleries and museums.
- Collect collage materials, such as sweet papers, coloured papers, card, wool and other textiles, beads, buttons and collected foreign labels. Collect newspapers and magazines when abroad – different language text can help to reinforce work about visits to different countries.

Memory board photos of Kerala – I arrange my photos on large, A1 boards to help recapture memories of a location.

TEA PLANTATIONS KERALA

In my painting of the tea plantations in Kerala, southern India, I began work by spending some time looking at the memory boards (see left) and picked out in my mind some of the things that seemed most important to me and would best describe my visit there.

I loved the shapes of the channels between the tea plants where the workers walked and picked the tea. Also, the row of trees was particularly appealing as were the wider pathways and white fencing. All these features appear in my finished painting.

I have used texture gels to describe some of the channels, blue and pink oil pastel resists to show the undulating hill shapes, and I have made the trees decorative with collaged and patterned papers.

The overall effect gives the sense of a green patchwork, and the vastness of the plantation is felt by taking the pattern right to the edges of the paper – a sense of the 'never ending'.

USING MEMORY BOARDS

When I travel, I always take lots of photographs of the places I visit, as photographs provide one of the main ways to remember my visit. The first thing I do is to create several 'memory boards'. I try to keep themes going on each board – the one show opposite, for example, was of a day at the tea plantation in Kerala. Sometimes, however, they represent patterns and textures that I have seen throughout the visit, or perhaps images of doors, and so on.

I place the boards all around the studio so that when I begin to paint I can try to re-capture the sensations and feelings experienced in that place. Sometimes I let the images catch my eye randomly, or more carefully choose particular shapes to try to re-create a particular subject matter in the painting.

Try working like this. It is not only a good way to begin, but also it helps to sustain memories and provides a place you can refer to when you are not sure where to go next with your picture.

Washes of watercolour are placed over lines drawn in pencil selected from a selection of photos. Masking fluid is drawn to 'save' the lines of fencing which will be white eventually.

Lines are added in oil pastel, describing the undulation of the hills and walkways between the tea plants. A layer of watercolour wash is added.

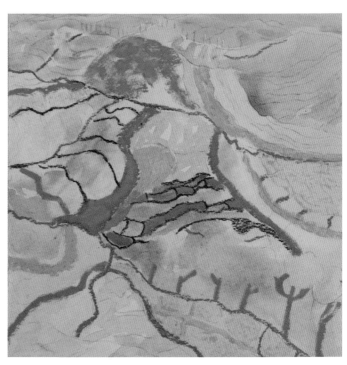

Some texture gels are applied and additional washes of watercolour are layered on top.

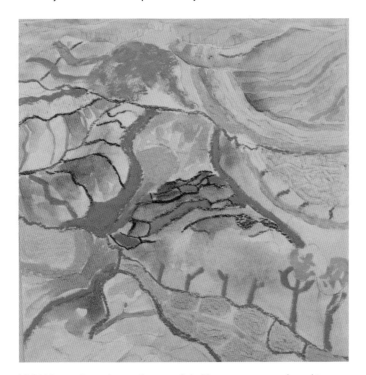

Light blue and purple acrylic are painted in some areas and used to describe waterways and tree trunks.

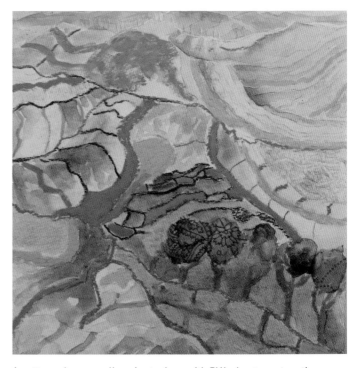

A patterned paper collage is stuck on with PVA glue to portray the foliage on the trees. Bright green pearlized liquid acrylic is used to highlight some parts. Small areas are painted with watercolour washes.

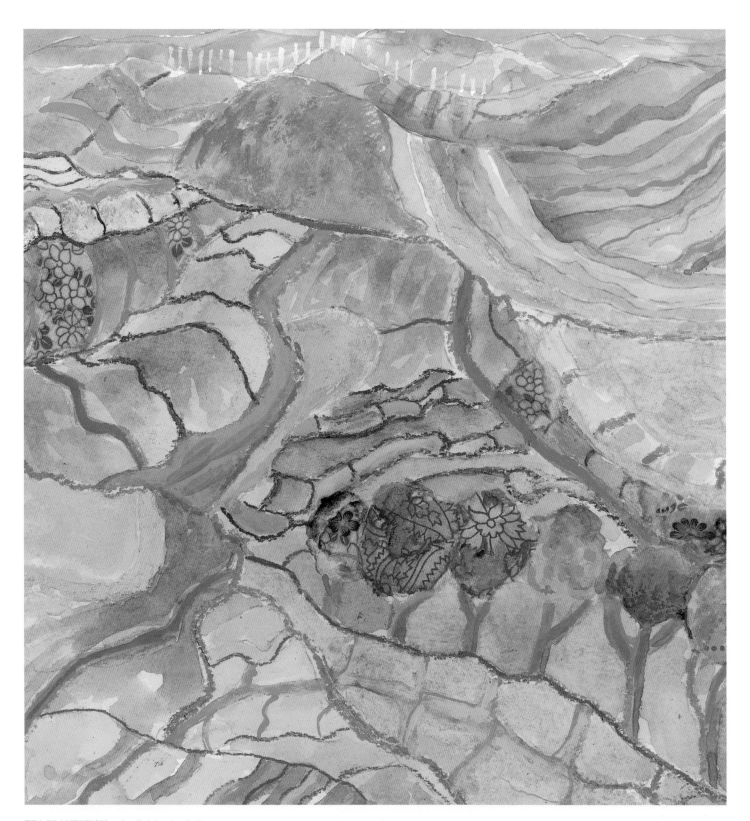

TEA PLANTATION – the finished painting.

DIFFERENT INTERPRETATIONS
MAGGIE MATTHEWS

The source of Maggie Matthews' work is clearly the beach and the sea near her home in south-west England. She makes many sketches outside, working rapidly to try to absorb and capture the essence of the moment. But it is in her studio – which she calls her 'sanctuary' – that she carries out her paintings. She chooses her colours to 'reflect the ambience of a day', perhaps to reflect heat or maybe the prevailing weather conditions such as wind or fog. She looks for abstract shapes in the landscape and has a large collection of shells and pebbles. These act as mementos, having been 'shaped by time', and present an endless variety of forms which fascinate her. She paints with mixed media and is also a screenprinter.

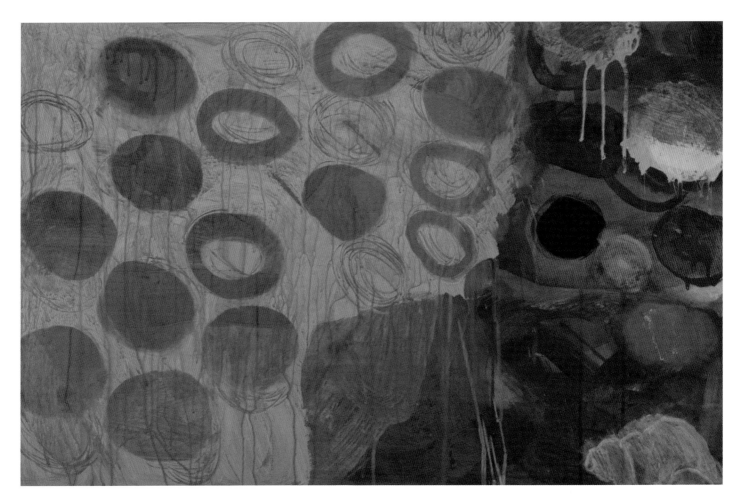

WATERCOURSE-WATERSPLASH
Mixed media on paper, 54 x 81cm (21 x 32in)

Maggie Matthews has allowed drips and spindly blue marks to convey a watery feel to this painting, which seems to shelter a hidden 'stash' of shells and other beach-bound forms.

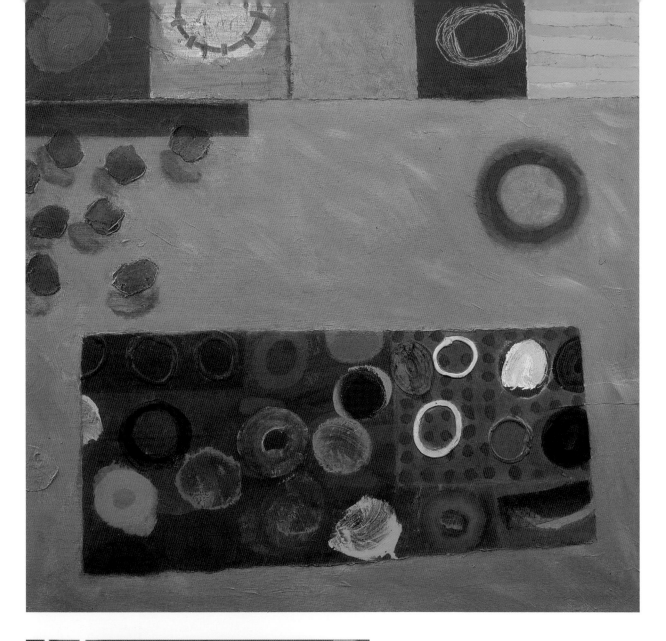

ROCKPOOL

Mixed media, 90 x 90cm (35½ x 35½in)

Again, vibrant colours have been used in this wonderful painting.
Simple circles in dark blue represent rocks and boulders, while lighter and
brighter colours suggest reflections and shadows on the pool floor. It feels
as though the viewer is hovering overhead, gazing down into the pool.

MEMENTO

Mixed media on paper, 76 x 100cm (30 x 40in)

The rich colours and gold and silver gilding of some of the objects
bring a kind of 'majesty' to the everyday beach objects in this
painting. They could almost be hidden treasure.

PEBBLE POOL

Screenprint, 45 x 60cm (18 x 24in)

I love this vibrant screenprint which describes
perfectly its title with its varied round forms
(the pebbles) interspersed with more organic
'animal' forms, all portrayed in translucent,
vibrating colour.

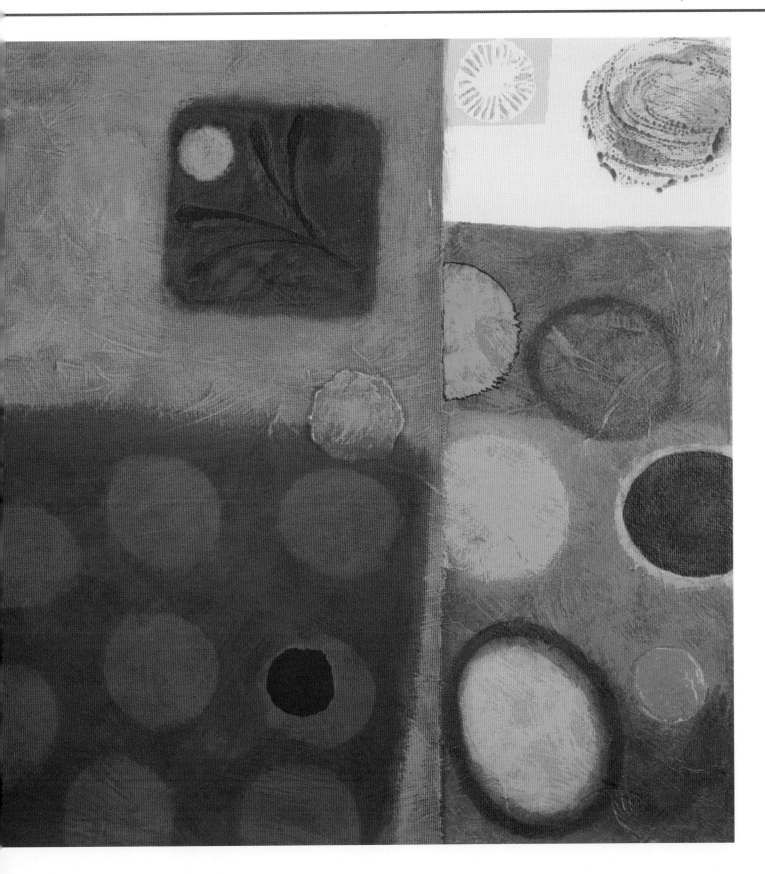

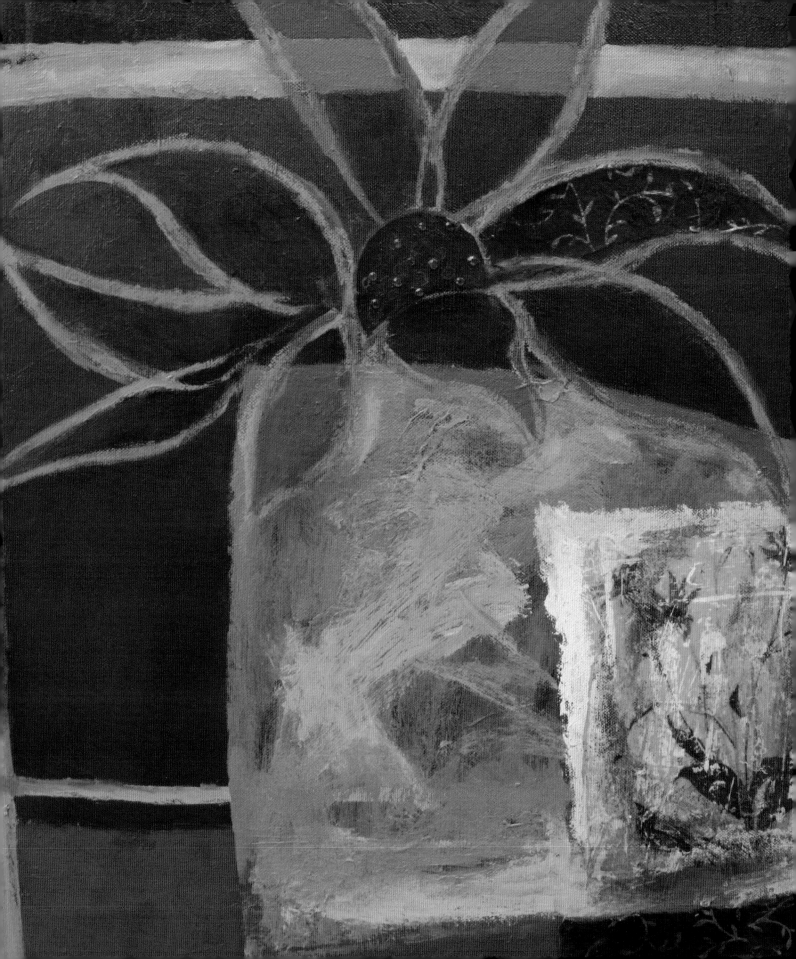

8 FROM REALITY TO ABSTRACTION AND BEYOND

For me, finding ways to paint abstracts is a process of lateral thinking – always trying to look 'outside the box' in order to paint something personal and fresh. As we have seen so far, there are many factors that come into play. These fall into three steps:

1 What do you want to paint? The subject can be actual things, places or people or it can be a painting about a painting – ideas from marks, thoughts or responses.

2 How are you going to go about making this painting and in what format: realistic or abstract rendition?

3 What materials are you going to use to do this and how are you going to use them?

This chapter is about that journey.

FLOWERS CONTINUOUSLY, SOMETIMES PURPLY RED
Mixed media on paper,
60 x 60cm (24 x 24in)

This painting is from a series about flower forms. Here they have been abstracted, stylized and designed as large motifs on the canvas. The small flower motif is from my book of botanical paintings.

THE JOURNEY

The journey towards abstraction can be a direct one (figurative to abstract image) or a backwards and forwards game (starting with a realistic image and painting an abstract image, or perhaps beginning with marks and then working towards an image). We have seen this in Chapter 7 where some figurative images were used as starting points (see page 86), and also in our exploration of 'inspiration from within' (see page 94). You can go forwards from the 'real' or back from the 'imagined'.

We are going to concentrate on a journey forwards from a realistic image. However, this time we are going to look at producing several images, each deriving one from the other. As our starting point, we will take a decorative, iron doorway and then abstract it (a little). Next, we will look at making a painting from this abstract version (more abstracted) and then making a picture that derives from the original image, but ends up being something entirely different.

THE PROCESS

I loved this contemporary ironwork gate because of the contrast between the hard material used to construct it, and the organic and soft shapes of the final piece. I also liked the figures – I don't usually find ways to include figures in my work, so this was a good way to incorporate them.

PENCIL LINE DRAWINGS

The first thing I did was to make several line drawings in pencil, so that I could get to know the shapes and see what I could do with this image. I ended up not only drawing the gate but also extending the lovely curvy lines beyond it towards the outside of the paper, allowing lines to cross over, making wavy shapes as well as lines. I decided to use the surrounding brick walls as another contrast to emphasize these curves with straight lines.

Photograph of a crafted metal doorway.

Line drawing with some lines extended to the edges of the page.

COMPUTER IMAGE

Next, I decided to play with this line image in my computer. If you have an art program, it is great fun to see what is possible, and it can give you ideas for your paintings. I scanned one of my drawings and tried filling shapes with flat colour, keeping the lines lighter, so that they stood away from these blocks of colour.

THE FIRST PAINTING

My first attempt has stayed quite close to my original line drawing. I have used a limited palette (mostly reds and yellows) and have developed the gate by filling shapes, emphasizing some of the curls and also the figures. Most of the outside lines are just that – lines. By doing this, I have made the gate a single motif. I kept my materials simple, too, using watercolours and gouache.

Line drawing scanned into the computer and 'coloured' in Photoshop.

Painting using a limited palette, highlighting the gate, making it solid and the surroundings linear (reversing reality). Watercolours, gouache and marker pen have been used.

THE SECOND PAINTING

This is an extension of the previous painting but I have developed the image considerably. Firstly, I have used a combination of mixed media – watercolour, oil pastels, acrylics, pen and some collage. The gate has been extended right to the edges of the paper and now has a more organic feel. The figures are less important as they are integrated and are following the general flow of the curves of the gate and also the leaf shapes (top left of the painting). There is much more movement in this picture and it feels almost as if it is bursting out of the boundaries of the rectangle. To allow it to 'breathe' a little, I have kept a few areas white and light.

THE THIRD PAINTING

In this painting, I wanted to use the important elements of the last picture but to develop it into something completely separate from the original subject matter. I studied the previous paintings for a while, turning them around and looking at them from all angles. When I turned them sideways, I saw that the curves were rather watery – almost like big waves. I deliberately selected a long, narrow piece of card – by changing the format like this, I could immediately imply the horizontal nature of the sea. I focused on the wave-like forms and used texture gel to create some swirling over the whole of the painting.

Once this was dry, I began to paint, using blues and greens, which are evocative of water. I then cut some more pieces of card in similar shapes, pasting them onto the surface. By painting them in purple they could be read as a slightly different space on the picture plane.

Finally, I printed some spirals with a card and string stamp (see page 42), added some thin painted gold lines and lightly rubbed oil pastels in gold and turquoise over the areas worked with the texture gel, just picking up parts of that texture. I was pleased with the overall effect, especially as it had derived from something so completely different.

AN ONGOING PROCESS

You can see how it is possible for this process to go on and on. If you are stuck for subject matter, try using this progressive method with photographs or perhaps go out into the garden and do some more direct observational drawings as your starting point. If all else fails, get out some old drawings or paintings and try to work from those. The important thing is to keep looking at each stage of the image, selecting and separating the parts you find the most exciting, and then developing them in turn.

An extension of the line drawing. The image has now been developed, using a wide variety of mixed media. The gate is no longer a metal object but altogether more organic. Movement has been emphasized.

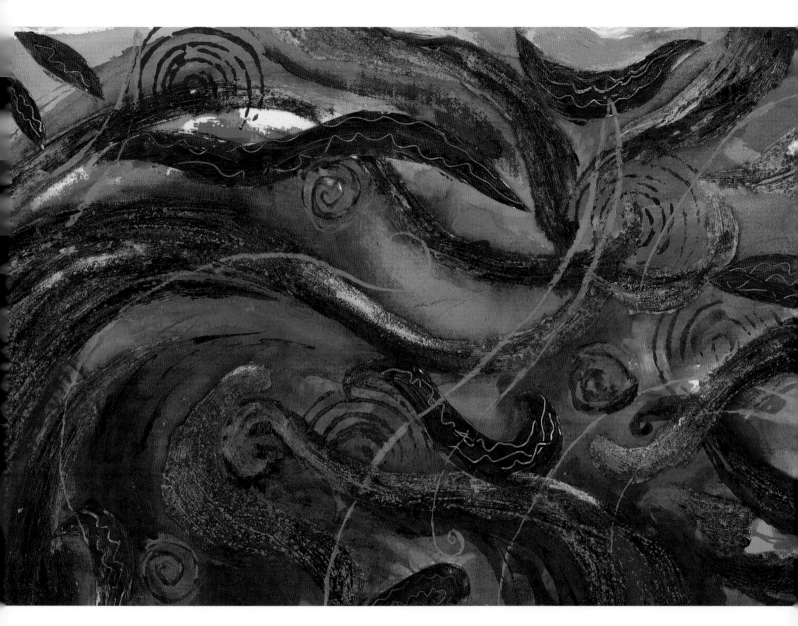

TURBULENT SEA
Mixed media on paper, 24 x 35cm (9½ x 14in)

The painting has been developed further and changed, moving it away
from its original source. Blues and greens have been used to evoke
water, and the curvy shapes on the gate have been selected to create
wave shapes. The figures have now completely gone.

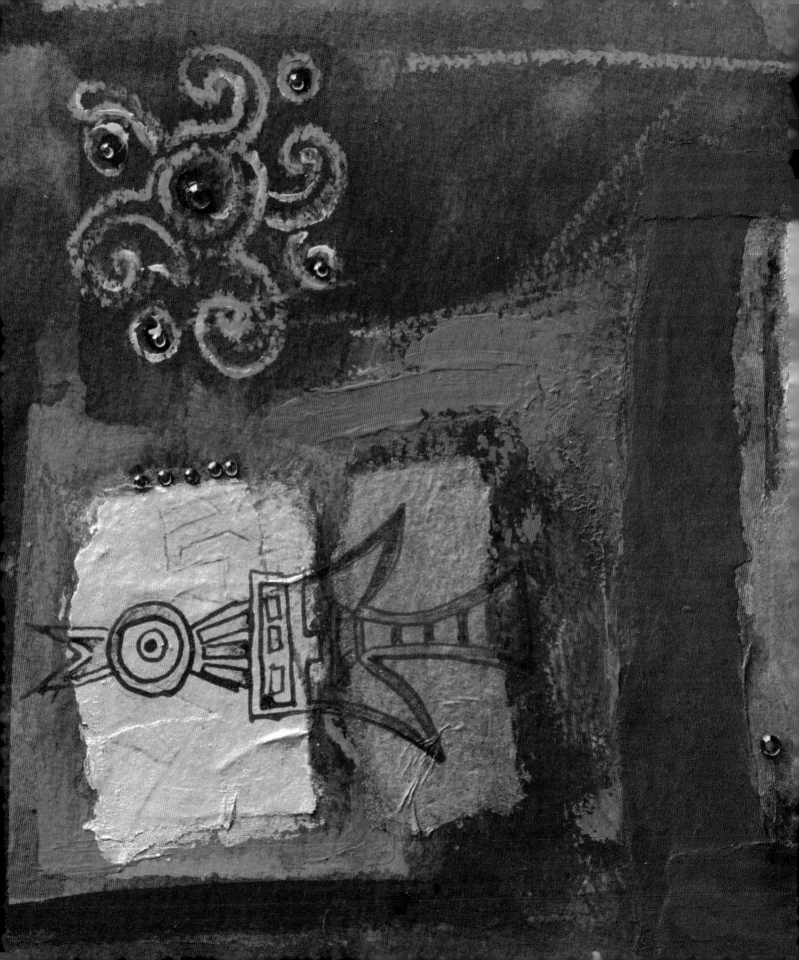

9 DEVELOPING A PERSONAL LANGUAGE

One of the ways to make your painting more abstract is to use symbols. They can encompass the essence of an idea, thought or action, and there are many ways to make them. Art is a visual language, which artists use to express themselves, and symbols have been employed as a means of communication since long before man invented the spoken word. Letters, the means we use to write down language, are symbols in themselves. As you develop as an artist, you build up a visual vocabulary – a kind of shorthand. Through experimentation and just 'doing' it, you will choose certain lines, shapes and colours more frequently than others. This is the personal 'handwriting' of art. This chapter shows you how to explore and develop your own language, finding personal symbols, and also how to design and recognize descriptive motifs to help you do this. A variety of approaches will be explored, using projects to guide you.

MEMORIES OF CUSCO
Mixed media on paper, 28 x 32cm (11 x 13in)

Just that – remembering this lovely city in Peru, visiting the museum with its precious objects and walking through the crowded covered arcade in the centre.

USING SYMBOLS

Start by trying to recognize shapes that turn up time and again in your work. Try keeping a record of these in a dedicated sketchbook (your symbol 'diary'). Experiment with lots of different materials and colours and, as you relax into the work, shapes and marks will emerge. This sketchbook will become a valuable resource for your paintings.

Keep looking through your diary, analyzing why you might have used these shapes – this will all add the 'personal' to your marks. I like the spiral: not only does it appear in many decorative aspects of the cultures I visit and use for subject matter but it also resonates with me as a shape representing the idea of continual change and energy. I use pinks and purples often – two colours I love. Both warm and sensuous, I find them appealing and exciting to use. I like to think that although my viewers may not know exactly why I have used a colour or symbol, hopefully, because I have used it with passion and conviction, they will be able to recognize this in my work.

Finally, doodle in your symbol diary when you are watching TV or speaking on the phone. You will be surprised what shapes pop out of your subconscious while you are concentrating on something else.

SYMBOLS ARE SHORTHAND

Symbols are a visual manifestation of unconscious thoughts and knowledge. They help to tell a story succinctly, summing up in the simplest way what we want to say. Many are universally described and understood. They fit into our lives and allow us to make quick decisions as we go about our daily routines. They include such things as traffic lights and road signs, labels in our clothing regarding washing instructions, signs on machinery and even notation like our postcodes! We all get to learn and understand these until we 'read' them without even thinking about it.

DESIGNING SYMBOLS

We have looked at ways to find and recognize our unconscious symbolic handwriting and how to access some of these hidden personal shapes by doodling. But there are more conscious ways to design elements in our paintings which can tell a personal story, using colour, line and shape.

COLOUR AND DEVELOPING A PALETTE

You can use colour to create a feeling or atmosphere. If you research the symbolic nature of colour, you will find many interpretations, which vary according to when and where they have been used.

- **White:** Purity, peace, cleanliness.
- **Black:** Death, sorrow, sadness.
- **Red:** Celebration, passion, danger.
- **Blue:** Unity, harmony, coolness or cold.
- **Green:** Spring, growth, fertility, earth.
- **Purple:** Royalty, mystery.
- **Yellow:** Joy, happiness, warmth.
- **Orange:** Energy, heat, fire.
- **Brown:** Nature, stability.

Here is a selection of simplified shapes to use as symbols.

Now, think about combining colours – creating strong contrasts can make a painting vibrate with excitement. Equally, using low-key harmonizing colours can tell a calm and gentle story. In short, think about what you might be portraying when choosing a colour scheme. It can be as simple as describing a cold day or as complex as describing emotions and relationships. Without clear, figurative clues, it is important to use your choice of colours carefully.

DESIGNING YOUR OWN SYMBOLS

Now we have looked at the symbolism of colour, we can extend our research to create a 'visual dictionary'. There are some universal shapes that are used singly or as components in symbols.

- **Circle:** Wholeness, infinity, the goddess and femininity.
- **Square:** Physical world and masculinity.
- **Triangle:** Number '3', the Trinity, goddess.
- **Spiral:** Continual change, universal growth.

Although there are many meanings for these shapes, they can be used to represent universally known ideas, and to help design your own symbols with their own meanings. Succinct and simple, these shapes are easily used and read.

DEVELOP MOTIFS

Work reductively and try to develop 'motifs'. Take a tree, for instance, and simplify the overall shape. Experiment with colour and try to find the 'essence' of the tree by describing, as simply as possible, the patterns of its branches or the rounded lollipop shape.

Continue to simplify and stylize the image until you feel that you cannot remove or change anything else but are still showing the 'treeness' of the tree. This way you can make a motif your own, allowing you to use it in your paintings with personal conviction. Take a look at Piet Mondrian's famous sequence of tree paintings for inspiration.

IDEAS FOR EXPERIMENTATION

- **Buildings:** Houses represent modern living and can be made with a triangle over a square.
- **Temples and churches:** Represent the spiritual; use a half-circle dome over a rectangle or a tall spire.
- **Animals and birds:** Simplify their shapes using half circles, rectangles and triangles. These can suggest the instinctive, freedom or the spirit.
- **Water:** A wavy line shows moving water; falling lines could be a waterfall. Water can symbolize the flow of life, the human spirit or force of nature.
- **Nature:** As with my tree example, simplify natural forms, such as flowers, mountains, lightning and so on. There are many forms and patterns to be found and borrowed from nature. You will find spirals, branching lines, circles, zigzags, and wavy lines – all can been used in this universal language.

MARKS, LINES, SHAPES

As we have seen in previous chapters, paintings are made up of many different components – colour, lines, marks and shapes. These are the essentials of picture making and, like colour, their direction, thickness variability and scale also represent meaning for us. Horizontal marks can be stabilizing and therefore have a 'solid' and 'dependable' feeling, whereas verticals 'grow' upwards and diagonals seem to 'fly'.

MAJORELLE GARDENS
Mixed media on paper, 32 x 29cm (12½ x 11½in)

This painting is inspired by the wonderful Majorelle Gardens in Marrakech. The major features of the gardens, as well as the tropical plants and flowers and ponds, are the vibrant cobalt blue pots, painted walls and mosaic floors. The sunlight created a beautiful checkerboard shadow of a trellis on a wall and I have featured that in the centre of the painting, emphasized by the 'checked' mosaic to its left.

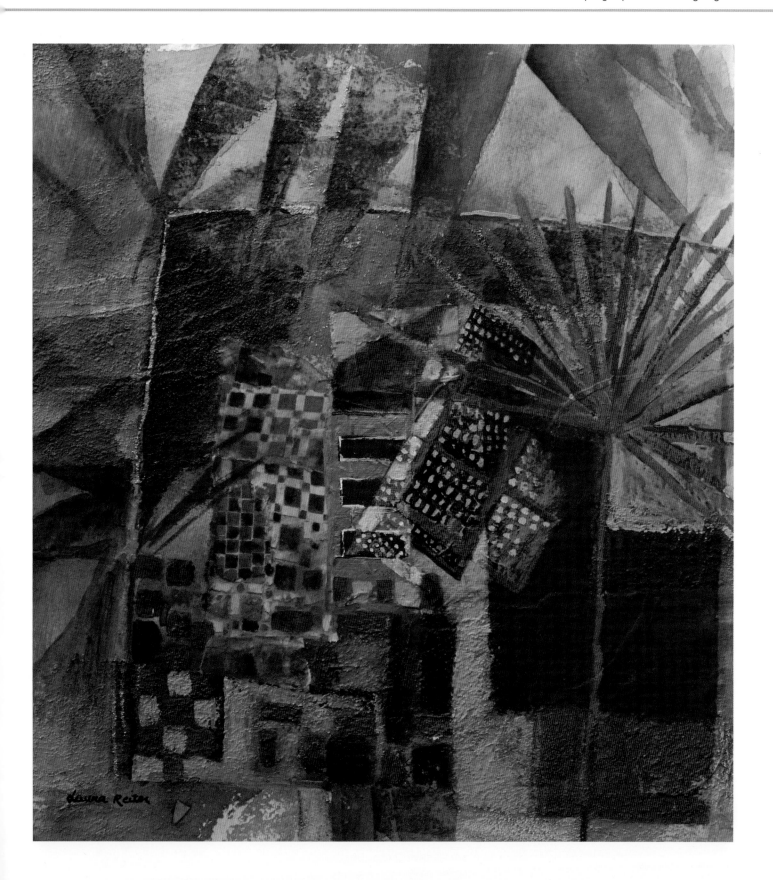

THE DESIGN ASSOCIATION GAME

Shapes, colours, lines and other marks can make associations in your head, creating feeling, narrative and atmosphere in your painting and contributing to your own personal visual language. Play a game with the shapes below and find out what associations you can make.

FITTING WORDS TO DRAWINGS

Look at the set of drawings and list of words below and see which, if any, words 'fit' with any of the drawings.

This game is subjective. You may have a different idea of these associations to someone else, or you may not be able to associate some at all. It does not matter. Think of a word that does make an association for you and try making some drawings of your own.

Try to describe the word in the simplest possible way. Then try doing this the other way around – make some marks and then find a name. Next, try adding colour to them. Keep a note of them all – they can be added to your visual dictionary.

GROWING RELAXED CELEBRATION
FIZZING CONFUSED AGITATED
HAPPY REGIMENTED PLAYFUL BUSY
GROUNDED SAD ROMANTIC
FLYING RIGID FUNNY
JOYFUL ANGRY

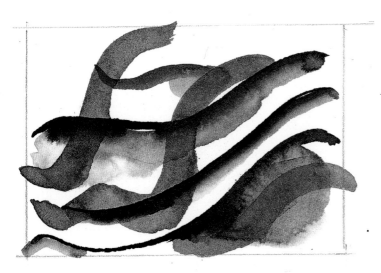

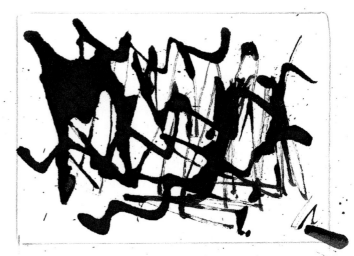

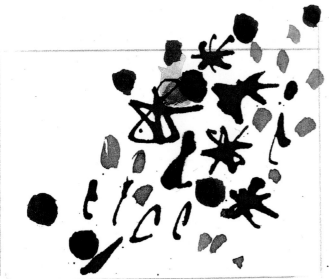

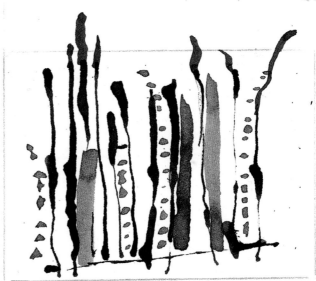

PROJECT

Having investigated the symbolic nature of art, you are now ready to apply what you have found out by making some paintings.

PREPARE TWO SURFACES

Throw washes of cool colours (blues and cool greens) on one surface, and warm colours (reds, yellows and oranges) on the other. Begin to build up these paintings with marks using transparent and opaque paint, inks and pastels. At this stage, think of an 'abstract' title for each – for example, 'Shiver' or 'Heated Moments' – which will encourage you to express abstract emotions.

WORK SIMULTANEOUSLY

Continue to work on these paintings simultaneously, moving from one to the other, trying to portray the titles you have chosen. This will keep the works fresh. Don't be tempted to put 'real' images in. Try to make each painting work with pattern, colour and marks – for instance, wiggly, thin lines might be a good way to describe 'Shiver' whereas intense red and orange circles could portray 'Heated moments'.

ASSESS AND REASSESS

At all times, remember to assess and reassess your painting, making sure, as in any other picture, that the design works. Remember all the aspects of picture-making that you have learnt from this book. Every mark on your painting asks a question elsewhere until there are no more questions to answer and then the painting is finished.

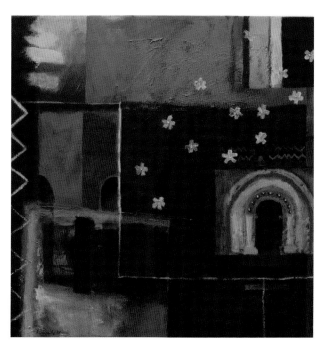

AFTER THE CONDORS
Mixed media on canvas, 61 x 61cm (24 x 24in)

This painting is about how, during a visit to Peru, we made an early morning trip to see condors flying. On the way back we came upon a little church, beautifully decorated with statues, arches, patterns and stunning colour. The doors were particularly lovely, set in an arch in this mint green colour. I have 'extracted' patterns from some of the décor inside the church and used the motif of the doors as the essential subject. We were at an altitude of more than 4,000 metres, so although it was brilliantly sunny with a bright blue sky, it was also very cold. I have used cool blues and bright yellows to evoke that contrast.

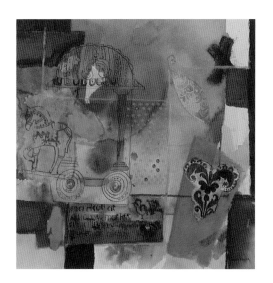

MARKET AT ALLEPEY
Mixed media on paper, 55 x 55cm (22 x 22in)

The hot colours in this painting are used to describe both the season and atmosphere at this market in southern India. I have used blues for the symbols and patterns as a contrast to give a sense of the hustle and bustle and general movement in the scene. The horse is an object I bought in the market, and the little stand on wheels represents an actual stand, which I loved despite being unsure what it was actually used for.

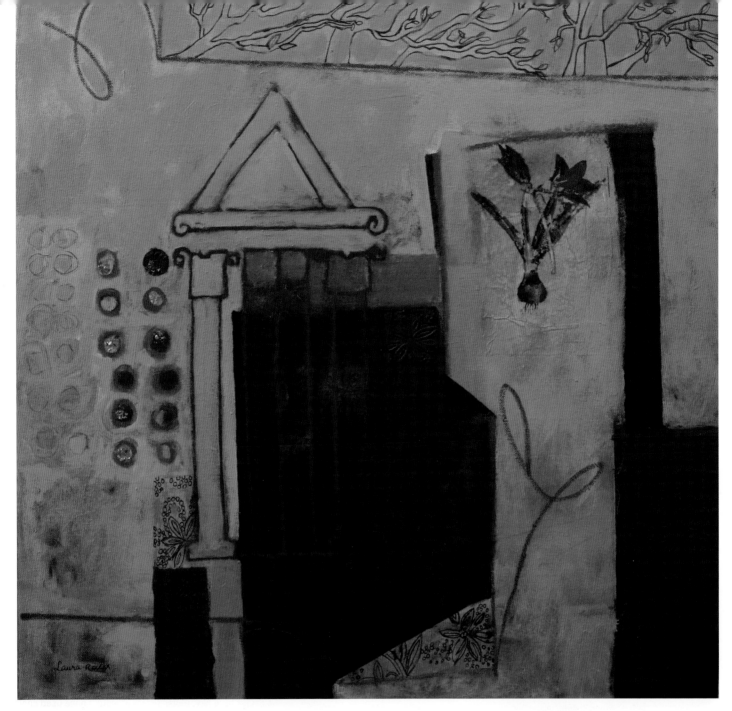

AMARYLLIS
Mixed media on canvas, 61 x 61cm (24 x 24in)

This painting comes from a series of paintings I made following two trips to Italy – one to Sorrento and the other to Venice. It reminds me of Venice – the blue canvas coverings on the gondolas and the blues on the buildings (together with the beautiful clear skies we were lucky enough to have). I've used the velvety red to represent the richness of the city, both in its treasures and the unique magnificence of the place. I have used more than one motif here: line drawings denote architectural elements, and branches are 'trapped' within a shape at the top of the painting to represent the gardens hidden among the ornate buildings. Finally, I have added an amaryllis flower image borrowed from a 17th-century botanical painting, which seemed to add to the 'Latin' nature of the painting.

DIFFERENT INTERPRETATIONS
ANUK NAUMANN

Anuk Naumann uses objects and scenes as subjects for her paintings and up to this point she knows what her paintings are going to be about. However, she does not know (or want to know) what the end result will be until she has completed the journey of the work. Her personal language is very distinctive – simplified and stylized forms, intense colour and atmospheric tone. Having been trained initially as an architect, she felt the need to break away from straight lines and become 'looser', but the element of design is very important to her and the resulting images tell stories of places and of things all living in their own vibrant world.

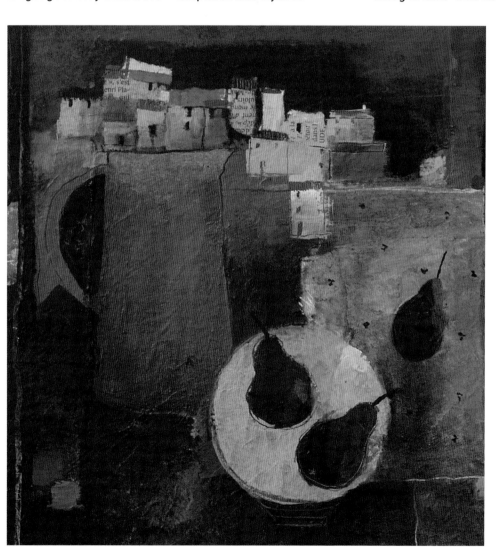

THE ORANGE JUG
Mixed media on paper, 20 x 20cm (8 x 8in)

Here, the painting tells a story. Objects are recognizable but simplified and stylized. The buildings in the distance (simple rectangles) give context and distance. The orange of the jug is by far one of the strongest and largest areas of colour and even if the title were not 'Orange Jug' we would still know that this was what the painting was about.

WHITE CHINA AND FIGS
Mixed media on paper,
50 x 50cm (20 x 20in)

The simplicity of the portrayal of the objects and the warm glow of the oranges, browns and pinks in this painting evoke a cosy atmosphere. This picture makes me think of a gathering on a summer's night. The contrasting purple of the figs, and the dark striped bowl – more solid than the other objects – seem to put them centre stage.

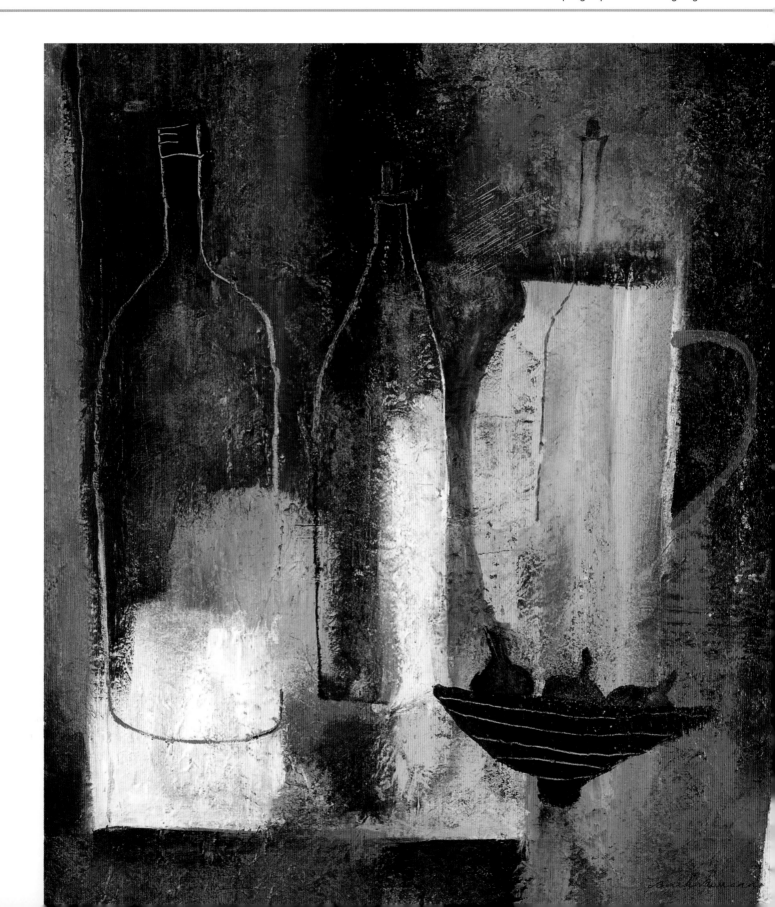

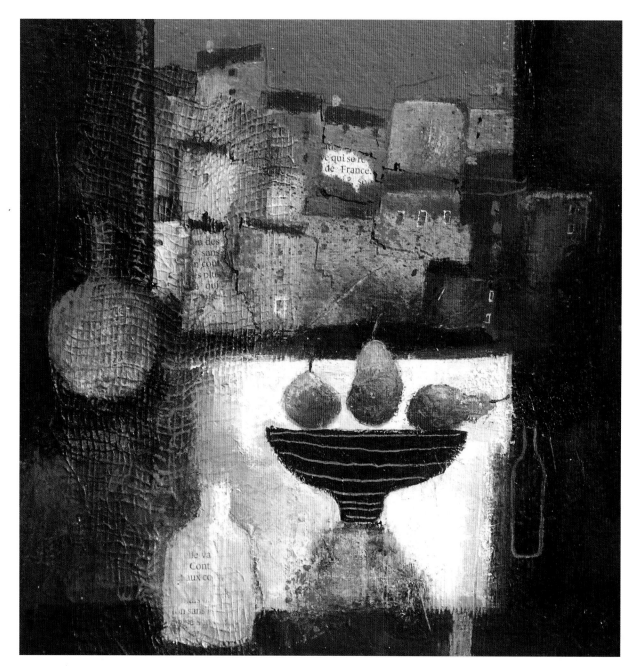

THE FRENCH WINDOW SILL
Mixed media on paper, 20 x 20cm (8 x 8in)

<div align="right">

ANEMONES AND RED BOTTLE
Mixed media on paper, 20 x 20cm (8 x 8in)

</div>

The bowl from 'White China and Figs' (see previous page) features here again. Objects are recognizable but are simplified shapes and the pink sky and tiny piece of collaged text, telling us that this is France, evoke an atmosphere of a warm, French summer's night. However, the highlighted fruit (lit by the moon perhaps) seem to have been given the starring role. The chunky collage gives a rustic feel.

<div align="right">

The objects in this painting seem to be on show on their 'tipped up' table top with its white cloth. There is more geometry in the painting as a whole. I love the fact that, for a moment, you don't see the anemones, being initially distracted by the blue dish, and then suddenly there they are.

</div>

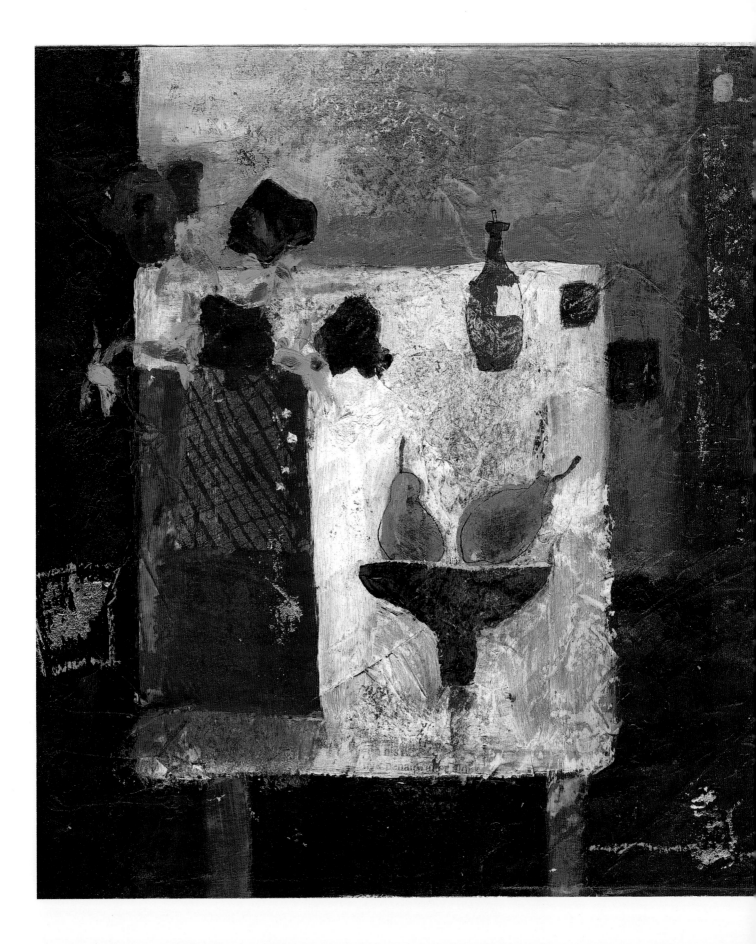

INDEX

PLUMERIA
Mixed media on canvas, 51 x 62cm (20 x 24in)

I found trips to Rome, Venice and Amalfi particularly inspiring, and this painting evokes one or all of these places, perhaps at dusk, hence the darker blues and black areas. In this painting I have gently suggested architecture, referred to tiled flooring and used Italian botanical flowers and a leaf as an extra Italian ingredient.